艺术与科学的对话
DIALOGUE BETWEEN ART & SCIENCE
第二届中国新疆国际艺术双年展作品集
A WORKS COLLECTION OF THE 2nd XINJIANG INTERNATIONAL ART BIENNIAL, CHINA

第二届中国新疆国际艺术双年展组委会 编
鲁晓波 杨冬江 主编

中国建筑工业出版社

2nd Art

The 2nd Xinjiang
International Art Biennial, China
第二届中国新疆国际艺术双年展

第二届中国新疆国际艺术双年展 /
THE 2nd XINJIANG INTERNATIONAL ART BIENNIAL, CHINA

主办单位 / HOSTED BY

中华人民共和国文化部
MINISTRY OF CULTURE OF THE PEOPLE'S REPUBLIC OF CHINA
新疆维吾尔自治区人民政府
THE GOVERNMENT OF XINJIANG UYGUR AUTONOMOUS REGION

承办单位 / ORGANIZED BY

中华人民共和国文化部艺术司
THE ART DEPARTMENT,
MINISTRY OF CULTURE, P. R. CHINA
中华人民共和国文化部对外文化联络局
BUREAU FOR EXTERNAL CULTURAL RELATIONS,
MINISTRY OF CULTURE, P. R. CHINA
新疆维吾尔自治区文化厅
THE CULTURAL DEPARTMENT OF XINJIANG UYGUR AUTONOMOUS REGION

展览时间 / EXHIBITING TIME

2016_10

展览地点 / EXHIBITION VENUE

乌鲁木齐市宏美术馆
MACRO ART MUSEUM OF URUMQI CITY

策展团队 / CURATORIAL GROUP

总策划 / CHIEF DIRECTORS
诸　迪 / ZHU DI
谢金英 / XIE JINYING
任　华 / REN HUA
穆合塔尔·买合苏提 / MUHETAER-MAIHESUTI

总策展人 / CHIEF CURATORS
鲁晓波 / LU XIAOBO

策展人 / CURATORS
杨冬江 / YANG DONGJIANG
王树声 / WANG SHUSHENG
白　钢 / BAI GANG

策展助理 / ASSISTANT CURATORS
王旭东 / WANG XUDONG
石　硕 / SHI SHUO
刘雅羲 / LIU YAXI
郭蔓菲 / GUO MANFEI
何夏昀 / HE XIAYUN
王晨雅 / WANG CHENYA
师丹青 / SHI DANQING
王之纲 / WANG ZHIGANG

目录 / CONTENTS

010
主题阐述 / EXHIBITION THEME

020
科技与智造 / SCI-TECH AND SMART MANUFACTURING

046
生态与人居 / ECOLOGY AND HUMAN SETTLEMENT

074
信息与智能 / INFORMATION AND INTELLIGENCE

096
自然与生命 / NATURE AND LIFE

119
空间设计 / SPACE DESIGN

123
后记 / POSTSCRIPT

主题阐述 / EXHIBITION THEME

鲁晓波 / LU XIAOBO

自人类诞生以来，科学研究自然奥秘，建构充满和谐与美的规律和秩序；艺术触发人类内心情感，描绘人类对外界和内心的不懈求索。二者互为呼应，驱动着人类文明的进程。

处于萌芽时期的艺术以获得基本知识作为前提，而同样处于萌芽期的科学则要依靠理性来摆脱远古的迷信，探索真理。公元前7世纪起，古希腊人怀着对世界的批判精神，对世界的本质和人的本体开始探索，这种哲学上的思考，巧妙地表现在古希腊人艺术观和科学观的融合上：美学家柏拉图将上帝描绘成一位几何学家；毕达哥拉斯用比率将数学与音乐联系起来，发现琴弦的长度与音乐音调之间有着奇妙的对应关系；神庙作为古希腊建筑艺术的最高成就则完美地体现着数学规律和几何定律。

经历千年禁锢，文艺复兴时期人文精神的苏醒将人们从封建神学的束缚下解放出来，并于16世纪达到顶峰，带来一段科学与艺术的革命时期，揭开了近代欧洲历史的序幕。在古典规范和科学精神的指引下，先哲追求艺术和科学的复兴。艺术与科学携手联盟，艺术发展的写实求真借助科学技法得到根本的提高；科学发展通过惟妙惟肖的刻画更好地实现其观察、记录自然万物的任务，诸多大师既是艺术家又是科学家，我们看到艺术家们对自我心灵的肆意表达，对世界所具有的真挚热爱、对人文精神的恒久表达以及对科学和理性的执着追求。达·芬奇是文艺复兴时期的著名画家、雕塑家、建筑师、哲学家、工程师和发明家，他从不拘泥于学科界限，研究范围涉及音乐、绘画、透视、数学、解剖学、光学、力学、植物学、地质学、工程机械、军事技术等领域。深厚的艺术表现力背后，其卓越的科学和技术贡献以及关于科学方法论的论述，不仅开创了新型的自然科学，对于文艺复兴晚期的自然哲学思潮以至整个近代新哲学的形成都具有重要意义。

自20世纪中期开始，人类社会跨入信息时代。计算机技术、多媒体应用、人工智能、虚拟现实等技术成果的出现对艺术活动产生了深刻的影响，不但对人们的生活产生了深刻的影响，更不断扩展艺术家的观念，丰富和更新其表达媒介，为艺术创造提供了更为广阔的表现空间和全新的表现语言，使得艺术呈现更加多元化的发展局面，世界用全新的创作素材、高科技的表现手段演绎着艺术家的认知。而伴随着现代科学整体化、综合化的发展趋势，艺术也不断地向科学灌注着无尽的创造力和丰富的想象空间，给予其人文精神的滋养，科学创造变得更为生动。

艺术与科学的联系如此密切，给人们带来美好的体验和悠远的遐思。开普勒的行星运动定律与巴洛克艺术的椭圆结构有着类似优美而神秘的结构、牛顿的物理光学实验为荷兰内景画的光线处理提供了深刻的视觉理论基础、量子论与修拉的点彩技法、相对论与塞尚的空间观念等也有着迷人的同构和千丝万缕的联系。

以"艺术与科学的对话"为主题的"第二届中国新疆国际艺术双年展"是对艺术与科学结合而产生的国际知名作品的一次全面集结，共划分为科技与智造、生态与人居、信息与智能、自然与生命四大部分，

这些作品将以开放的思维和角度体现当代艺术与科学领域的最新成果。

科技与智造

当今时代，世界制造业的需求导向正在重新生成，新一代信息技术与制造业深度融合引发影响深远的产业变革，形成新的生产方式、产业形态、商业模式和经济增长点。全球生产布局不断调整，体验经济、长尾经济、时尚经济等经济模式对生产方式提出了新的要求，智能制造、绿色制造、新型材料研究为各行业的转型升级、创新发展带来重大机遇和广阔的发展空间，这一切都更加催生了"智造"这一新现象的快速发展，它与"制造"的区别在于是否加入了更多研究与创新的因素，其中科技因素是重头戏。科技与技术的相互支撑，使"智造"深入影响到人类生活的方方面面。"科技与智造"单元包含了《自动驾驶》、《DIGITAL X》、《46号花瓶》、《3D打印婚礼》、《微生乌托邦》、《呼吸》、《鈝命》七件作品。其中，《DIGITAL X》将人与物之间的互动和相依相生体现得淋漓尽致；《46号花瓶》体现出数字技术推动创意产业中概念构思、加工制作和市场分配的转型；《自动驾驶》聚焦我们耳熟能详的驾驶体验，在科技对人的禁锢和自由之间为我们提供了耳目一新的解决方案，注重视觉统筹、虚拟信息与文化服务等因素更让我们深刻体会了共赢的魅力。

生态与人居

生态平衡是人居环境的基本法则，是人居环境的基本要求。随着现代社会的发展，城市化成为人类社会演变发展的重要主题。人类在享受城市化种种便利的同时，社会关系和环境平衡达到了某种微妙且危险的临界点。这一单元的作品，以前瞻性和批判性观念为先导，对城市形态与自然、环境关系不断反思，处处表达出"生态社会"的理念，以人、城市、自然的和谐共存为基础理念，将绿色环保的思想贯穿到城市规划、建筑设计和社会建设中，借助先进的数字化技术和科技观念，推动各领域朝着生态、理性和人文的方向迈进。《我脸上的雾霾PM2.5》是生动反映出国内当下敏感的环保问题的作品；《南极大陆：再循环》对于人类未知之境和未来发展提出极具创新思维和探索意识的思考和探索；《垂直村落》则聚焦于人们自由、多元化和灵活的邻里生活特点，尊重人的社群发展意识。

信息与智能

"信息与智能"是本次展览中最具特色的单元。21世纪以来，数字技术的飞速发展给艺术创作带来有力支撑，提供了全新的艺术构思方式和维度，诸如3D打印、信息可视化等技术为艺术造型提供了动态、交互、立体的全新模式，将视觉、听觉和触觉等人类主观感受充分融合到艺术表现语言中，推动原本指向精英个体的艺术形式更加亲近大众，人类的情感借助现代化的技术，以艺术的形式将原本冰冷的机械、计算设备和程序代码升级成为信息和艺术感受的双向交流融入公共生活，更加彰显现代社会的民主意识。本单元的作品包含《律动的城市》、《树的灵感》、《魔镜》、《韩熙载夜宴图交互长卷》、《遇唐·敦煌》、《阿凡达变形记》、《隐藏的机械舞者》。这其中既有通过信息化和智能化实现对人类历史和文物的艺术化展示和保护，也有通过信息记录、解析和转译以更加直接关注自然界，引导人们发现

最自然的生命的美好之作。

自然与生命

"自然与生命"是本展览中最具有灵动特质的板块，作品中有的构思宏伟、有的想象奇特，各有特色，反映着复杂而具有哲思的理论难题。一方面艺术家集中探索自然和人类的关系这一历史探求的永恒主题：人类与自然的对抗性导致全球性生态危机和社会危机，对人类持续生存提出严重挑战，应从人统治自然的文化向人与自然和谐发展的文化发展，开启人类文明的新时代。另一方面，基于生命的叙述与倾听万物的对话，以个体生命的存在本身来显现个体生命的伦理关切和尊重，也包含着不同的层面。于人类个体，如何真正保障个人的生命价值，防止其被"物化"和"异化"；于生物界，追求个体生命价值与尊严的凸显，打造自由自主的交流情景和开放的话语空间；于人和物的升华关系，探索"庄周梦蝶"的比物连类和不尽之谜。《超以象外》以艺术形式再现相对论这一经典的体现自然界基本力量之美的理论；《自问自答》以尽可能低耗高效的设计创造材料的形态之美、公用之需、生态之效；《无限的限制》将古老的物理实验以现代技术更好地呈现于人们面前。

本次展览以艺术与科学的联姻为线索，以对"人"的关注为中心，追求和表达人的内在的否定与超越精神，从时间与空间的维度辩证地推进人的双面回归和人的幸福生存与诗意栖居，使我们的视域更加广阔，思想内涵更加深刻，尽管有些作品不乏乌托邦的色彩，但其表现出的对人类生存状态的现实关注、对人与自然关系的伦理自觉、对人的本质实现的整体性迸发，都具有深刻的借鉴价值和现实意义。我们希望通过展示国际和国内艺术与科学领域前沿探索及学术研讨，揭示艺术与科学的内在关系，拓展和深化艺术与科学的研究，提高艺术与科学的创新水平，促进艺术与科学的和谐发展。展览所呈现的科技与艺术成果，将力求映射深层的人文景观和时代发展思路，引领人们进入科学与艺术的深层世界，以新的思路和方法探索与创造未来。

主题阐述 / EXHIBITION THEME
鲁晓波 / LU XIAOBO

Since the human came into being, the science has been studying natural mysteries to build up laws and orders full of harmony and beauty; the art triggers human's inner feelings and describes people's unyielding pursuit of the outside world and their inner soul. Art and science thus echo with each other to drive the progress of human civilization.

The art at its sprouting stage made it its basic task to gain fundamental knowledge, while the science at the same stage must rely on rationality to shake off ancient superstitions and seek truths. In the 7th Century BC, the ancient Greek started their exploration into the essence of the world and the human being proper harboring a critical attitude toward the world. Such philosophical thinking was skillfully reflected in the integration of art and science by the Greek: the aesthetician Plato described God as a geometrist; Pythagoras related maths with music by proportion, finding that the length of string is mysteriously connected to the tones of music; and as the ultimate achievement of ancient Greek architecture, temples perfectly demonstrates mathematical laws and laws of geometry.

After imprisonment for thousands of years, the revival of humanistic spirit during the Renaissance liberated people from feudal theology and came to a climax during the 16th Century, thus opening a revolutionary period of science and art and unveiling the modern European history. Under the guidance of classical norms and scientific spirits, sages sought the revival of art and science. Thus, art and science managed to progress hand in hand. The pursuit of realism in art development was fundamentally improved by virtue of scientific techniques, while science achieves better in observing and recording everything in nature by vivid depiction. Many masters were both artist and scientist, from whom we find artists' free expressions of their hearts, their sincere affection for the world, their eternal expression of humanistic spirit and their persistence to pursuing science and rationality. Da Vinci is a famous painter, sculptor, architect, philosopher, engineer and inventor during the Renaissance Period; he was never confined to boundaries of disciplines and expanded his researches to music, painting, perspective, maths, anatomy, optics, mechanics, botany, geology, engineering machinery and military technologies. Behind his powerful expression of art, Da Vinci's outstanding contributions to science and technology and his elaboration on scientific methodology have not only launched new-type natural science but pose great significance for the shaping of the whole new philosophy in modern times.

Since mid 20th Century when the human society entered the information era, the emergences of technological fruits like computer technology, multimedia application, artificial intelligence

and VR have exerted profound impact on art activities; they not only show power in people's life but help boost the ideas of artists to enrich and update the media of their expressions, thus providing greater room of expression and brand new expressional languages for artistic creation to bring about more diversified development of art. By new materials for creation and hi-tech means of expression, the world demonstrates the perceptions of artists. And following the trend of integrated development of modern science, the art is continuingly implanting creativity and imagination into science to give it the support of humanistic spirit and make scientific creation more vivid.

Such a close relationship between art and science has offered people nice experience and deep longing. The law of planetary motion advocated by Kepler and the oval structure of Baroque art share a beautiful yet mysterious structure; the Optical-Physics Experiment of Newton laid a solid foundation of visual theory for light treatment of interior picture of the Netherlands; there're also intriguing isomorphism and countless ties between the quantum theory and the "en pointille" created by Seurat and between the relativity theory and the space concept of Cezanne.

The 2nd Xinjiang International Art Biennial, China themed "Dialogue between Art and Science" is an all-round collection of world famous works due to the combination of art and science, lying in the four parts of sci-tech and smart manufacturing, ecology and human settlement, information and intelligence and nature and life. The works shown are intended to present latest achievements in the domain of contemporary art and science with open minds and perspectives.

Sci-tech and Smart manufacturing

In the modern world, the demand orientation is reshaping in the world manufacturing, and the in-depth integration of information technology with manufacturing is arousing far-reaching industrial reforms to give rise to new modes of production, new industrial forms, new business models and new economic growth points. With the continuing adjustment of global production distribution, economic models like the experience economy, the long tail economy and the fashion economy have posed new demands for the mode of production, and smart manufacturing, green manufacturing and research of new materials have brought about great opportunities and wide room for development to the transformation and upgrade and innovative development of all industries: all these have facilitated the rapid growth of "smart manufac

turing", whose difference from "manufacturing" lies in whether more elements of research and innovation have been added, and the key element is the science and technology. The mutual support between sci-tech and technology makes "smart manufacturing" penetrate into all aspects of human life. The module "sci-tech and smart manufacturing" includes seven works, namely, Auto Drive, Digital X, Vase #46, Wedding from 3D Printing, Utopia of Microorganisms, Breath and Life of Rust. Digital X gives a vivid depiction of the interaction and mutual reliance between men and objects; Vase #46 shows how the digital technology boosts transformation of conception, processing and market allocation in the creative industry; Auto Drive is focused on the driving experience familiar to all of us and provides novel solutions to balance between sci-tech's imprisonment of human beings and freedom, and its emphasis on overall vision planning and virtual service of information and culture pushes the charm of win-win onto our hearts.

Ecology and Human settlement

Ecological balance is a fundamental of human settlement and the basic requirement for human settlement. With the development of modern society, urbanization has become an important theme of the evolution of human society. While enjoying conveniences of urbanization, the human being is confronted with the situation that the social relations and environmental balance come to some tricky and dangerous critical point. Works of this module are led by foresight and critical ideas, with reflections on urban forms and the relationship between nature and environment, and fully demonstrate the concept of "ecological society"; based on the idea of the harmonious co-existence among humans, the city and the nature, the idea of green and environmental protection runs through urban planning, architectural design and social building in these works, so that they help guide all fields toward ecology, rationality and humanity by virtue of advanced digital technologies and sci-tech concepts. "PM2.5 on My Face" is a vivid reflection of the sensitive issue of environmental protection; "The Antarctica: Recycle" gives very innovative and exploratory thinking about the unknown situation and future development of human beings; "Vertical Villages" focuses on free, diversified and flexible neighborhood, respecting people's awareness of community development.

Information and Intelligence

"Information and Intelligence" is the most unique module in the expo. Since the start of the 21st Century, the leaping growth of digital technology braces artistic creation strongly and guarantees brand new methods and dimensions of artistic conception. Technologies like 3D printing and information visualization build up brand new dynamic, interactive and three-dimensional

models to fully integrate human senses like vision, hearing and touch into the languages of artistic expression so that the artistic forms originally pointed at elite individuals become closer to the average people, and by modernized technologies, human feelings and emotions manage to upgrade the formerly cold machinery, computing equipment and program codes into two-way communication between information and artistic experiences to be injected into the public life and demonstrate the democratic awareness of the modern society. This module introduces works like "The Energetic City", "The Inspiration of the Tree", "The Magic Mirror", "Interactive Scroll of Han Xizai's Banquet Drawing", "Encountering Tang and Dunhuang", "Avatar's Transformation" and "The Hidden Mechanical Dancer", among which there're artistic display and protection of human history and cultural relics through informatization and intelligentization and wonderful works that pay direct attention to the nature and guide people to seek the most natural life through recording, analysis and translation of information.

Nature and Life

"Nature and Life" is the liveliest module in the expo. Some of the works are grandly conceived while some others feature fantastic imaginations; various characteristics reflect complicated and philosophical problems of theory. On the one hand, artists had concentrated explorations into the relationship between nature and human beings, the eternal theme of historical pursuit. The confrontation between the human being and nature has caused global ecological crisis and social crisis, posing serious challenges as to the sustaining survival of the human being, so that the culture of "man governing nature" should evolve into the one of "harmony between man and nature", thus opening a new era of human civilization. On the other hand, based on narration about life and dialogue with creatures of nature, showing individuals' ethical care and respect by the existence of individual lives can lie in various layers. For human individuals, it's about how to guard the values of people's life and prevent it from being materialized and differentiated; for the biological world, it's about the pursuit of the values and esteem of individual lives and the creation of a free and spontaneous scene for communication and an open discourse space; for the upgraded relationship between man and things, it's about exploring the comparison between man and nature and endless mysteries. "Beyond the Boundary" reproduced the classical theory of relativity that reflects the beauty of fundamental strengths in nature by artistic means; by low-consumption and high-efficiency designs, "Self-Questioning" creates the formal beauty, public use and ecological effect of materials; "The Limitless Limitation" better shows the ancient physical experiment by modern technologies.

Following the marriage between art and science, the expo is centered at the attention to "human" to seek and express internal spirit of negation and transcendence and dialectically promote the two-sided return of human beings and happy survival and poetic dwelling of them from the dimensions of time and space, so as to further broaden our horizon and deepen our thoughts. Though some works feature hues of utopia, their attention to people's living conditions, their ethical awareness of the relationship between man and nature, and their holistic manifestation of human nature boast great value for reference and practical significance. We hope that by exhibition of works and academic discussions in the leading edge of the international and domestic fields of art and science, the internal relationship between art and science can be revealed, researches of art and science can be broadened and deepened, innovation of art and science can be improved, and harmonious development between art and science can be guaranteed. The achievements of sci-tech and art shown in the expo will try hard to reflect deep-lying human landscapes and thoughts of development of the era, lead people into the deep-lying world of science and art, and explore into and create the future by new thoughts and methods.

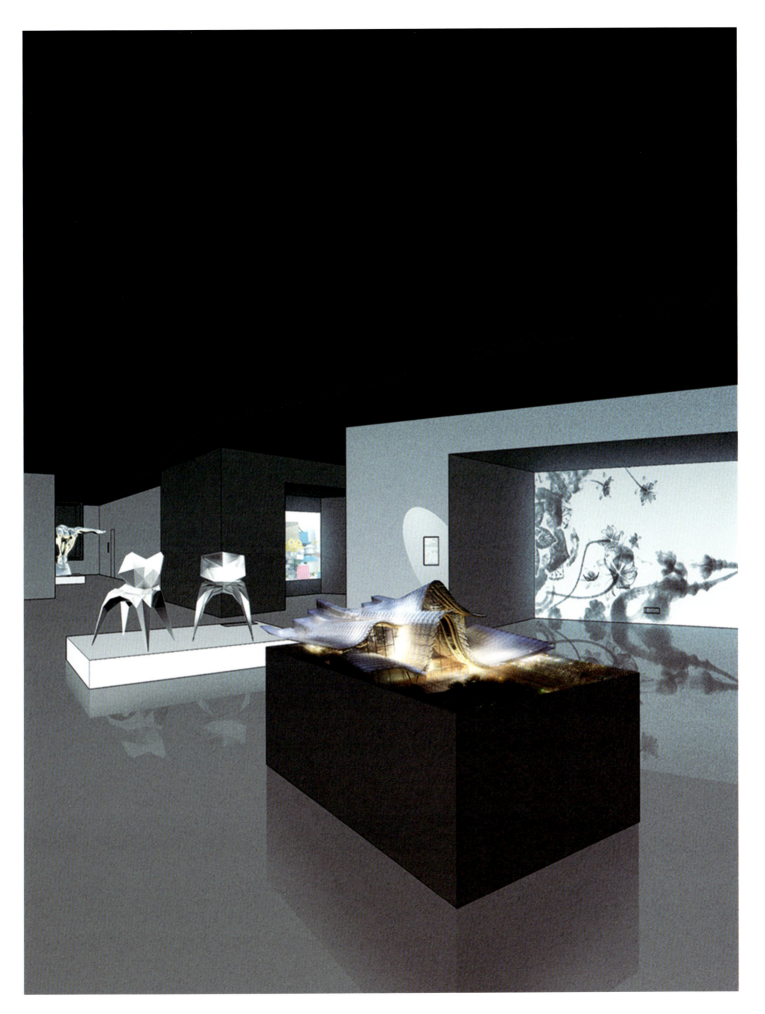

科技与智造

SCI-TECH AND SMART MANUFACTURING

自动驾驶 /
AEON

DIGITAL X /
DIGITAL X

46号花瓶 /
VASE#46

3D打印婚礼 /
3D PRINTING WEDDING

微生乌托邦 /
MICROSCOPIC

呼吸 /
BREATHING

鉎命 /
METAL LIFE

自动驾驶 / AEON

迈克尔 · 哈勃恩（卢森堡）/ MICHAEL HARBOUN (LUXEMBOURG)

还在为你本可以去很远的地方但大部分时间却被困在拥堵的交通上而感到苦恼？"自动驾驶"对在交通设备上使用增强现实技术进行了探索。

驾驶汽车经常存在一个悖论，一方面我们因此获得自由，另一方面我们经常被困在拥堵的交通上。谷歌之类的很多公司已经在研发能够自动驾驶的汽车，他们为我们提供了是否要亲自开车的选择。汽车如果可以自动驾驶，我们在车里的时候可以做什么呢？

当我们在自动驾驶的车里旅行时，可以通过选择不同应用得到独一无二的体验。程序根据我们的需求用3D显示和文字等方式将信息呈现在我们面前，车窗上的视觉信息、音频的音量、车内空调的温度都可以自动调节。在旅途中我们可以选择是否在车窗上接收更多的视觉信息。这样的自动驾驶在未来会变成日常生活的一部分。

"自动驾驶"的应用程序可以由文化事业单位开发，借此提升城市遗产的知名度。用户通过这样的应用程序能够了解每一栋建筑背后的故事和城市的历史。任何人都能开发"自动驾驶"的应用程序，大众的创造积极性会让这个系统越来越完善。

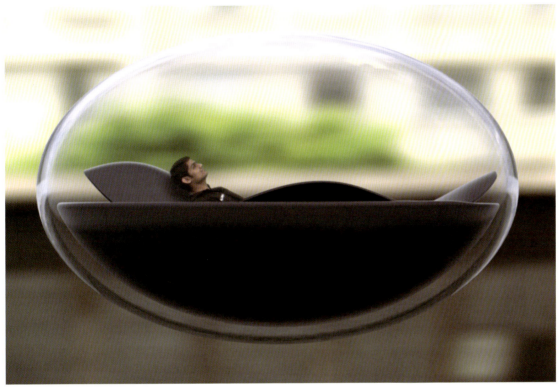

创作年代 / Date
2010

材质 / Material
视频 / Video

时长 / Running Time
04:56

What if you could travel to far-away destinations while being stuck in traffic? In collaboration with Dassault Systems I have been exploring the use of augmented reality inside transport vehicles.

Driving a car has always revealed a paradox. On one hand it can be considered as symbol of freedom, and on the other hand, as an activity full of restrictions. Companies such as Google are already working on autonomous cars. They will give us the choice whether we want to drive or not. So what will we be doing in our cars if we're not driving anymore?

When travelling inside Aeon, the user can live unique experiences by selecting different applications. While experiencing a quest, he can decrease or increase the amount of virtual information appearing on the window via a meter. Similar to audio volume or temperature. I think that virtuality will also become a common unit which we will be regulating in our everyday life.

Applications could be created by cultural institutions in order to promote cities' patrimony. The user would be able to visualize the stories behind each architecture and learn the history of the city. But applications could also be created by anyone, giving thus the possibility to create a community of experience-creators motivated to share their imagination.

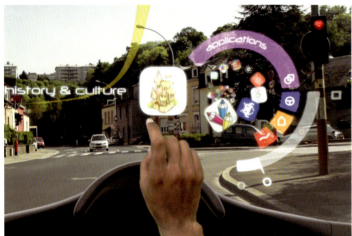
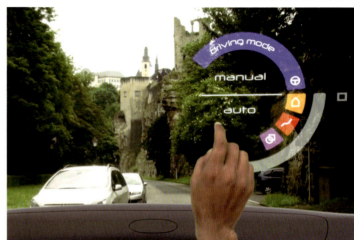
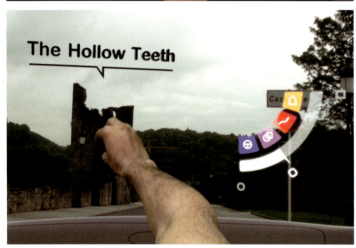
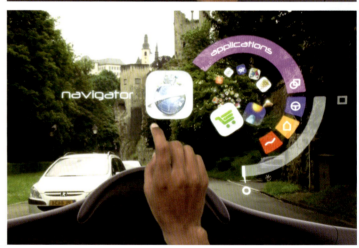
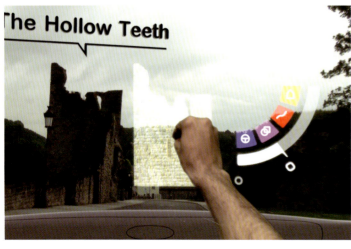
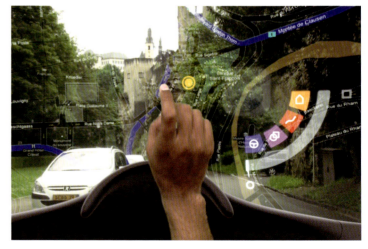

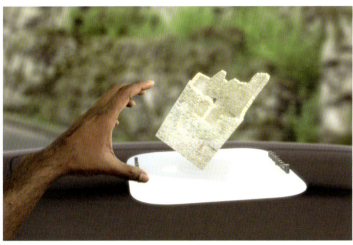
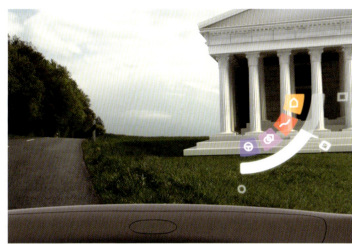
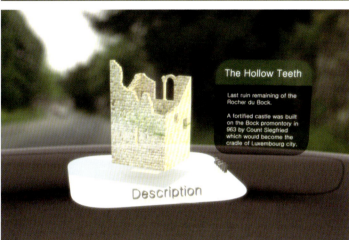

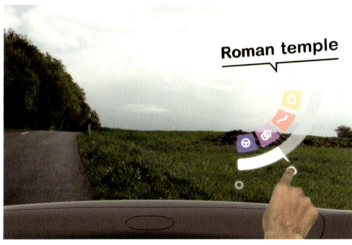

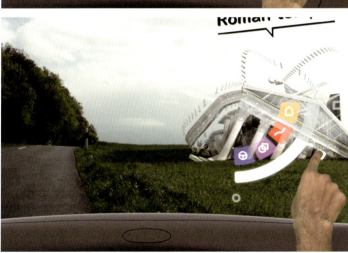

DIGITAL X
张周捷（中国）/ ZHANG ZHOUJIE (CHINA)

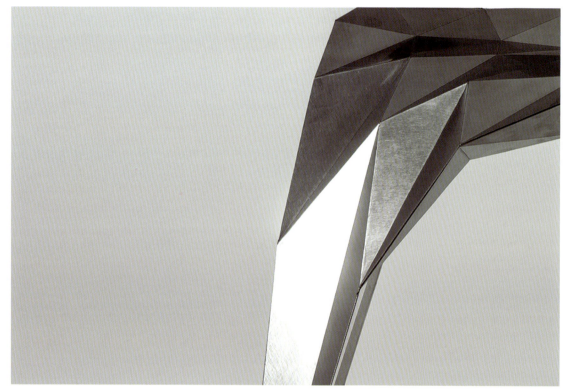

创作年代 / Date
2014

材质 / Material
不锈钢 / Steel

尺寸 / Dimension (cm)
长×宽×高 / Length×Width×Height
57.5cm×57.2cm×81.7cm

我相信我们已经身处数字化的时代，数字产物的可能性指日可待。同时，我也相信在数字化的环境下，物品会像在大自然中的生长一样，是有机的，我们只需要去探索为什么发生和如何发生。

张周捷作品依附古老悠久的道家思想："无为"、"自然而然"等哲学理念与当代数字手工艺和高科技相融合。DIGITAL X是他近期的系列作品，X的可变性代表了这种新型数字化生产中形状、材质、数量的无限可能性。张周捷团队自己研发的程式，将设计师定制家具的效率和准确度提升到一个新的高度。DIGITAL X系列便是与建筑师、室内设计师、开发商、精品酒店以及独立客户紧密合作下的产物。

I believe we are in digital age already and approaching the foothills of what is possible with digital objects. I believe that objects in digital world will grow as nature does, in an organic way, but we just need to discover why and how that happens.

Zhang ZhouJie has been celebrated the world over for his merging of contemporary craft and high-tech processes whilst adhering to a centuries-old daoist philosophy of flow and non-intervention. Digital X is the latest in this series where X represents the infinite number of forms, materials, and quantities possible through this new state-of-the-art manufacturing platform. A proprietary software developed by Zhang's in-house team has scaled custom, designer furniture production to new levels of efficiency and precision. Close partnerships with interior designers, developers, architects, boutique hotels, and celebrity clients has led to the creation of the Digital X line.

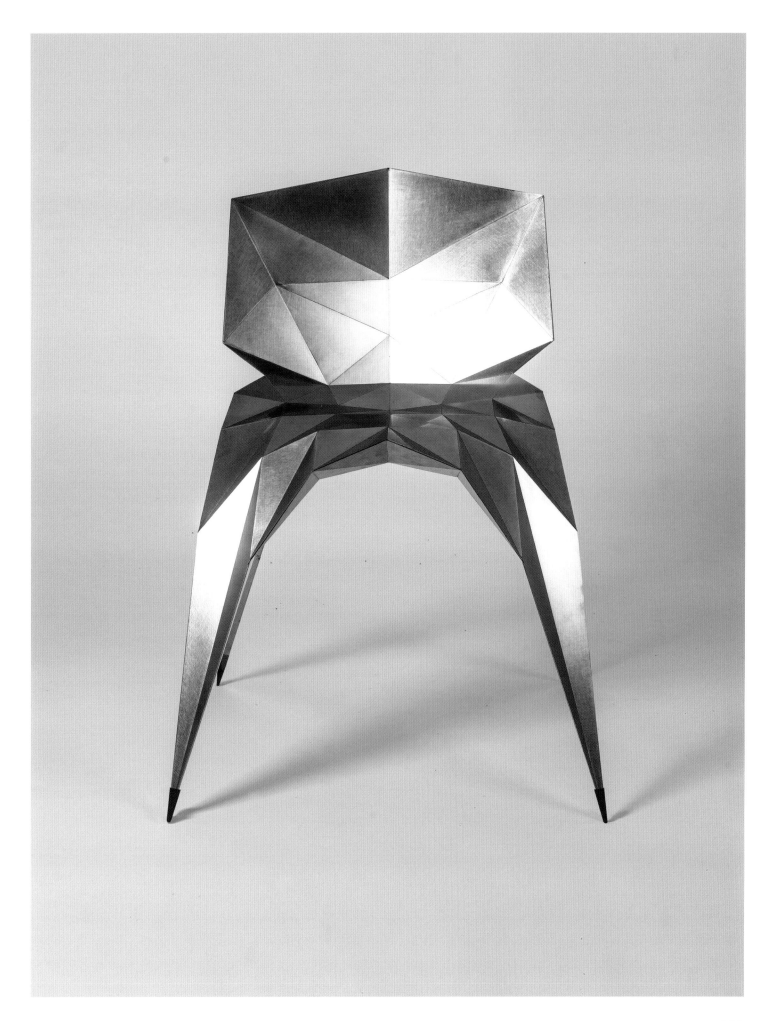

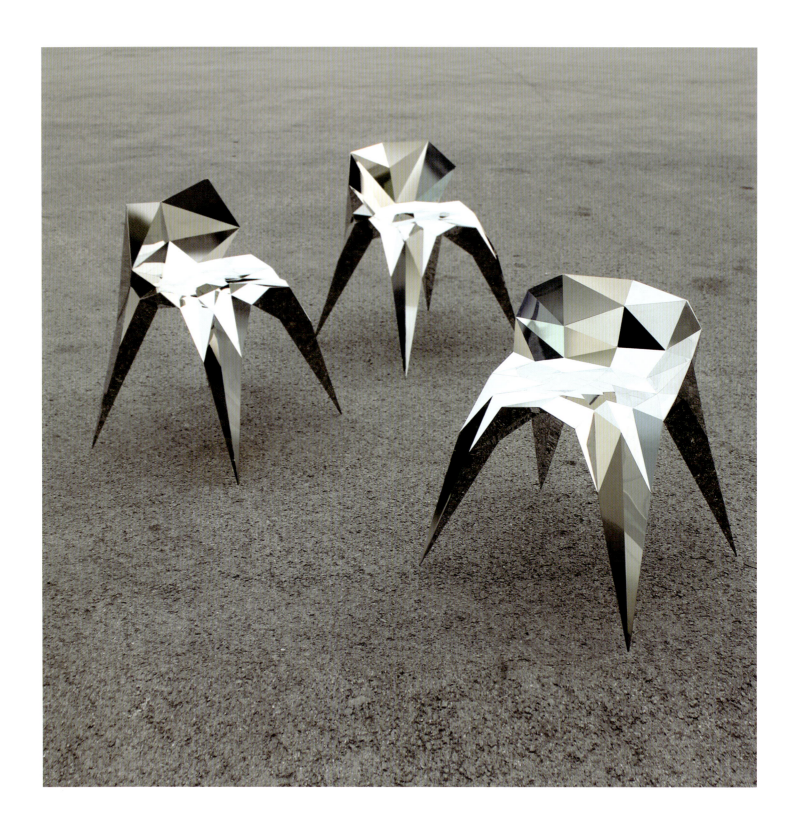

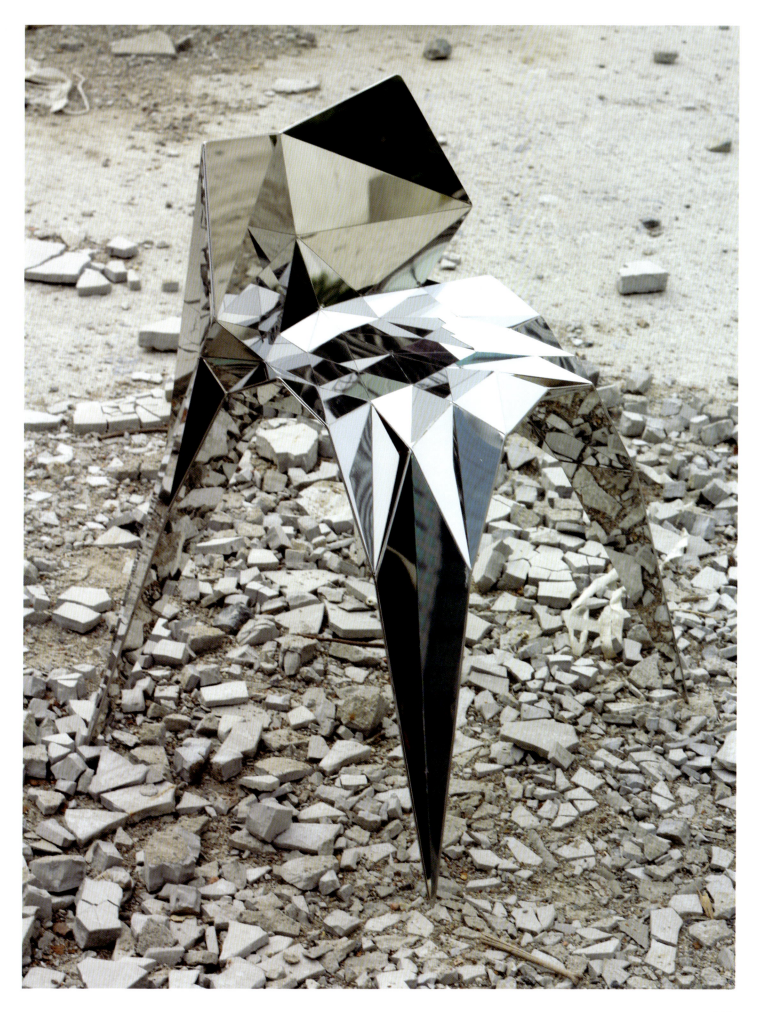

46号花瓶 / VASE#46

弗朗索瓦·布吕芒（法国）/ FRANCOIS BRUMENT (FRANCE)

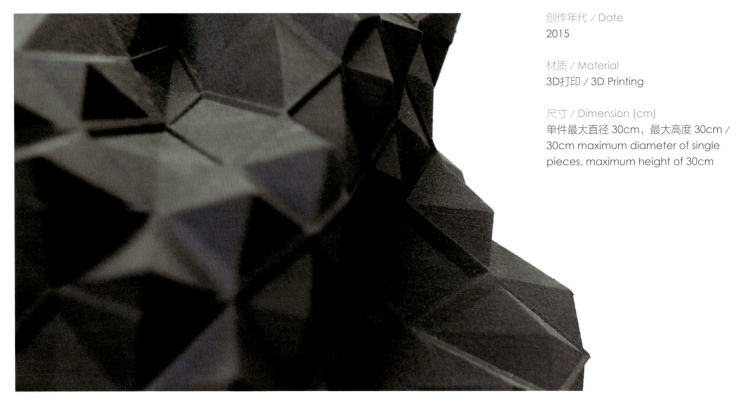

创作年代 / Date
2015

材质 / Material
3D打印 / 3D Printing

尺寸 / Dimension (cm)
单件最大直径30cm，最大高度30cm /
30cm maximum diameter of single pieces, maximum height of 30cm

"数字技术正推动着创意产业中概念构思、加工制作和市场分配的转型。"

"Digital technologies transform the phases of conception, manufacture and distribution of objects."

《46号花瓶》是一组由声音雕塑而成的器物。创造者的声音被收录、解码、编码后通过计算程序打印出不同形态的花瓶：声道截止的一瞬间，你可以在屏幕上看到模型的构造，紧接着后台程序自动生成了花瓶的制作文件，最后基于"选择性激光烧结技术（SLS Technology）"的3D打印机生产出你的"作品"。

Vase#46 is a series of objects whose form is generated by the sound of the voice. Every vase is the result of a given voice captured and converted to shape by an algorithm wrote by the creator. Once the soundtrack ends the model is fixed, and the programme automatically creates the production files that serves to manufacture the object by 3D printing with SLS technology.

互动体验说明：
请讲话、呼气、吹口哨……

Instructions:
Speak, blow, whistle...

发声越久，花瓶越高；声音越大，花瓶的肚子越大。声音的频率从高到低决定着瓶体上的波浪纹理。

Longer is the sound, higher is the vase, stronger is the sound, wider is the vase. Sound frequencies produced, from highs to lows, affect the ripple of the vase.

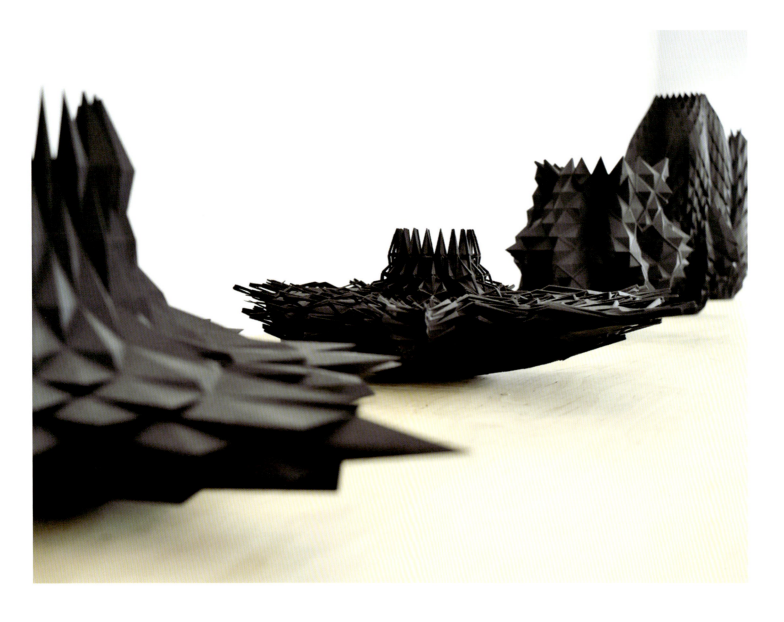
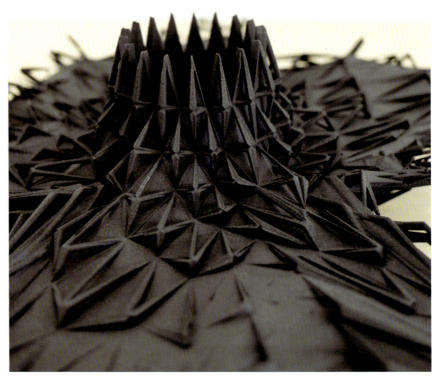

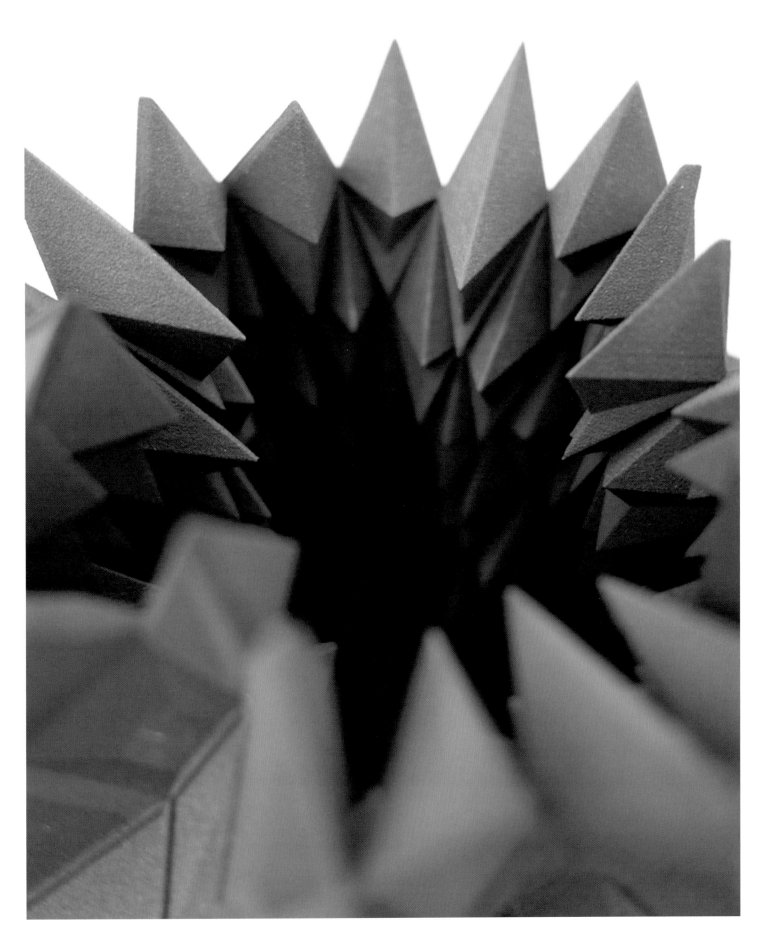

3D打印婚礼 / 3D PRINTING WEDDING

马子聪、王蕾、李宣吉、汪侃天、克里斯托·库哈斯、鲁彬、赵曦晨、张悦（加拿大、中国、希腊）/
MA ZICONG, WANG LEI, LI XUANJI, WANG QIANTIAN, CHRISTOS KOUKIS, LU BIN, ZHAO XICHEN, ZHANG YUE (CANADA, CHINA, GREECE)

3D打印婚礼当中所运用到的灯具、喜糖盒、部分餐具、首饰、甚至包括结婚戒指、手捧花、婚纱等全部都是由3D打印制成。极致盛放团队把这些小而美好的事物称之为日常生活美学。我们认为，那些宏大的建筑虽看似雄伟，但其实和普通人的生活并无太大联系，反而是一个精美的茶杯或者一盏好看的台灯，会更加的令人满足。因而，我们把这种日常生活的美学理念贯穿于3D打印婚礼的始终。

从雅致纤巧的工艺品到大尺度的构筑物设计，我们都希望能通过3D打印将其发挥到极致。融合看似冲突的元素，以其新颖的外形和材料在当下脱颖而出，也能在空间与功能的塑造上追求永恒。

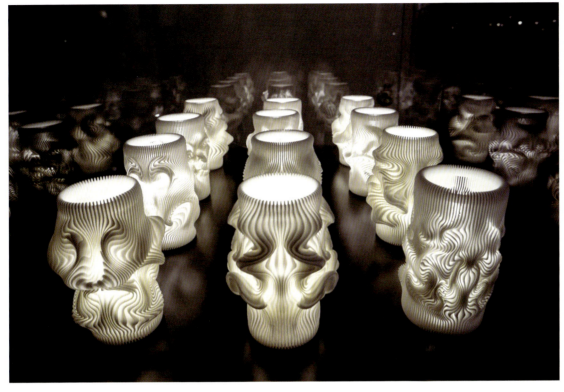

创作年代 / Date
2015

材质 / Material
尼龙，不锈钢 /
Nylon, Stainless steel

3D printing is a kind of thing that can be involved in everyday life rather than only in untouchable things. Xuberance team call these small and beautiful things everyday aesthetics. We believe magnificent buildings and architectures can be weakly connected with common life, while a delicate tea cup or one pretty lamp can satisfy people's beauty demand in everyday life.Xuberance's 3D printing wedding followed this belief. The lights, wedding cadies boxes,utensils and wedding accessories, even the rings, bridal bouquets and wedding dress are 3D printed. Therefore, we put the daily life connected through 3D printing wedding always.

We hope to maximize the quality of our products through 3D printing from exquisite crafts to large-scale structures. Novel appearance and new material make our product outstanding and unique. Xuberance focuses on integrating seemingly conflicting elements as to create excellent production spatially and functionally.

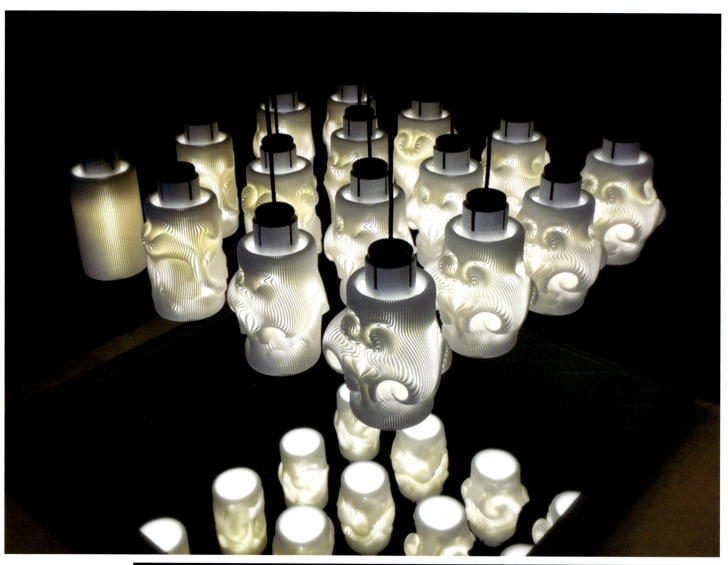
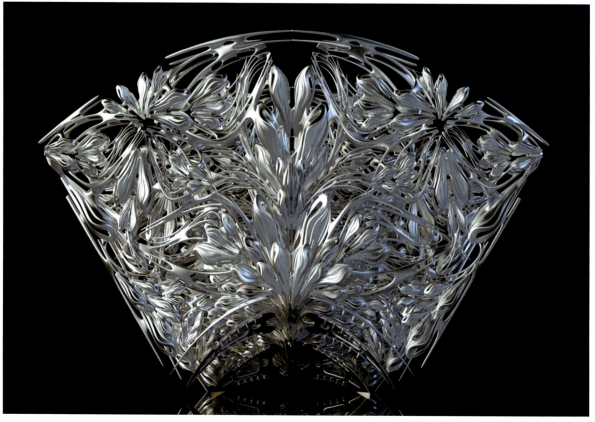

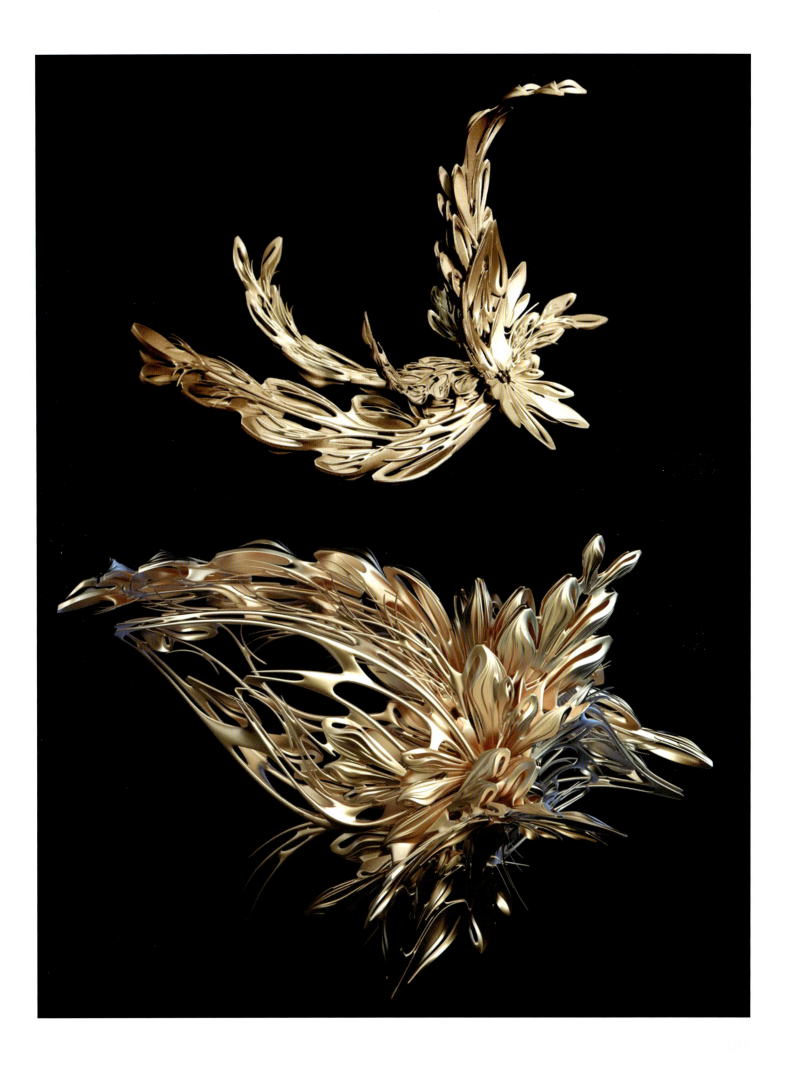

微生乌托邦 / MICROSCOPIC

王悦（中国）/ WANG YUE(CHINA)

创作年代 / Date
2016

材质 / Material
棉布，绡 / Cotton, Raw silk fabric

当今，日益发展的工业需求、膨胀的人口与自然环境之间的矛盾加剧。到未来的某一个点，人类的数值将会减少并稳定在一个区间。人类生存所必需的物质，都可以由一个细菌或者被改造的"自然工厂"完成，机械重复的劳动将被替代。

作品基于"天人合一"的中国传统哲学理念，致力于探寻可持续发展的染色技术。通过对菌种干粉的复苏、接种、培养和发酵，直接利用红曲霉菌、紫色杆菌以及小球藻等微生物所分泌的天然色素，辅助以媒染剂，对面料进行着色并形成纹样。"细菌染色"是以一种对人和环境负责的态度，以尽可能低耗高效的设计去创造材料的形态之美、公用之需、生态之效。

Till present, the changes in the environment here even threatened the human itself.The contradictions among the growing demands of industry, the booming population and the incompatible nature will never get reconciled.To a certain time, the population will get smaller and smaller due to the constant wars and the self-consistency, and with the reduction of human reproductive ability and the newborns, the number will fall to a steady interval. Without plants or vehicles, the human necessities will be achieved by a bacteria or a modified natural "factory". Mechanical repetition of the work will be replaced.

Based on the Chinese traditional philosophy idea "unity of man and nature", we are committed to seek a sustainable way for dying. Our method directly utilizes microbes such as Monascus, Aspergillus and Chlorella as well as pigments secreted by them to dye the cloth with the aid of mordants. It would also be possible for us to control the shade of the color by limiting the density of microbes, the concentration of dyes, temperature, the dosage of mordants and the duration of incubation. "Dying with microbes"holds a responsible attitude towards human and environment, and creates materials.

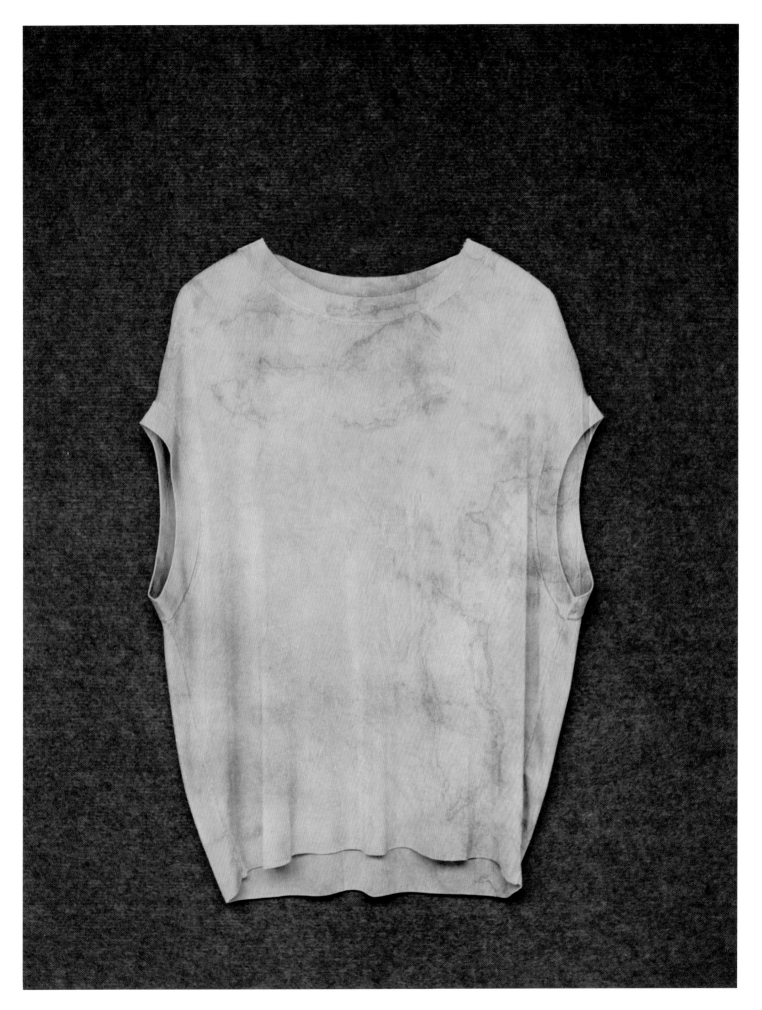

呼吸 / BREATHING

臧迎春、江竹婧（中国）/ ZANG YINCHUN, JIANG ZHUJIN(CHINA)

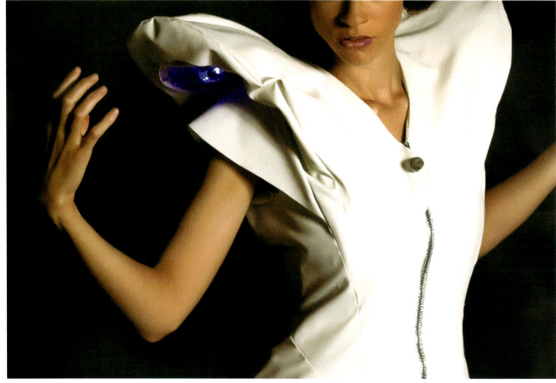

创作年代 / Date
2016

材质 / Material
仿皮革及综合材料 /
Artificial leather and synthetic materials

尺寸 / Dimension (cm)
长×宽×高 /
Length×Width×Height
170cm×60cm×60cm

针对日益严重的空气污染问题，该作品将时装作为一种装备，把纺织材料和新技术相结合，自带烟感和空气循环系统，对烟雾、酒精或有害气体可自动感应，使服装发出柔和地光亮，提醒着装者和吸烟者、酗酒者，然后带动双肩的风扇转动，为穿着者和周围的人提供新鲜空气。该作品将穿着者、服装和周遭的环境整合在一起，体现了从精神到物质层面对于可持续发展的社会状态的关注。

In view of the increasingly serious air pollution problem, this piece of art work use fashion as a kind of equipment, combining textile materials and new technologies, equipting with smoke sensor and air circulation system, which could automatic induct smoke, alcohol or harmful gases and using light to gently remind the wearer, smoking people and the alcoholics, in the mean time, drive the fan on the shoulders to rotate, to provide fresh air for the wearer and the people around. The work integrates the wearer, the clothing and the surrounding environment, reflecting the social status towards sustainable development are transform from the spiritual to the material level.

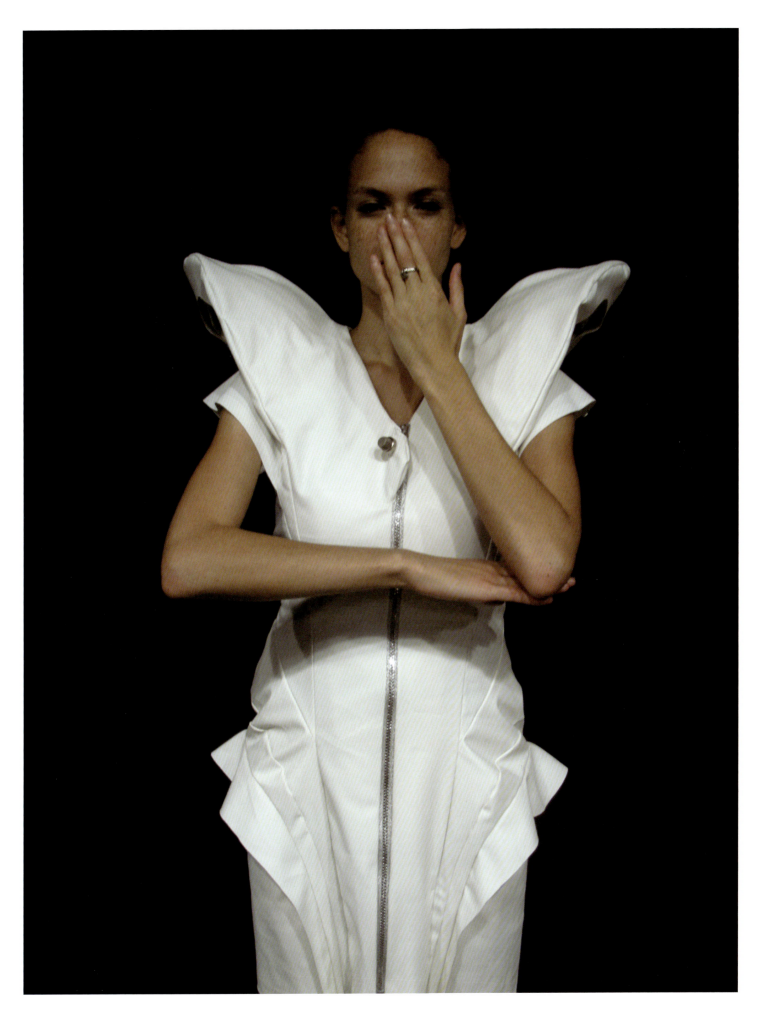

鈢命 / METAL LIFE

卢秋宇、王莉媛、麦龙辉、米海鹏、师丹青、徐迎庆、刘静（中国）/
LU QIUYU, WANG LIYUAN, MAI LONGHUI, MI HAIPENG, SHI DANQING, YU YINGQING, LIU JING (CHINA)

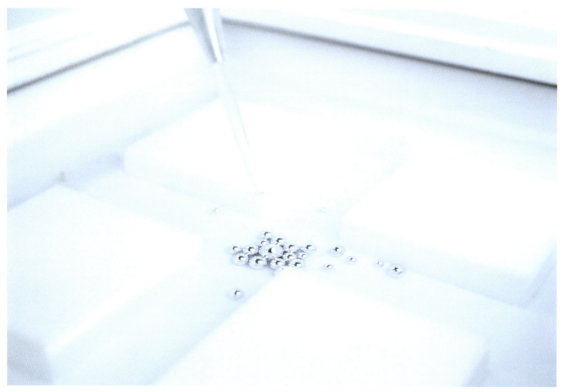

创作年代 / Date
2016

材质 / Material
镓铟合金，亚克力 /
Gallium indium alloy, Acryl

什么是生命？如果一滴液态金属可以捕猎、进食、消化、游动，我们是否可以认为它是有生命的？《鈢命》是一组饲养着液态金属软体动物的交互装置。生活在装置中的液态金属软体动物仿佛真的具生命与自主意识，在与参与者互动时会表现出害羞、好奇、淘气等不同的性格，引发参与者对于究竟什么是生命的思考。

What is life? If a drop of liquid metal can prey, eat, digest and swim, can we say that it is alive? "Metal Life" is a series of interactive installations in which liquid metal molluscs are raised. When people interact with the molluscs, the molluscs will exhibit different characteristics (shyness, curiosity, naughtiness, etc) as if they are alive and conscious. The interactive installations will arouse a rethink about what life is.

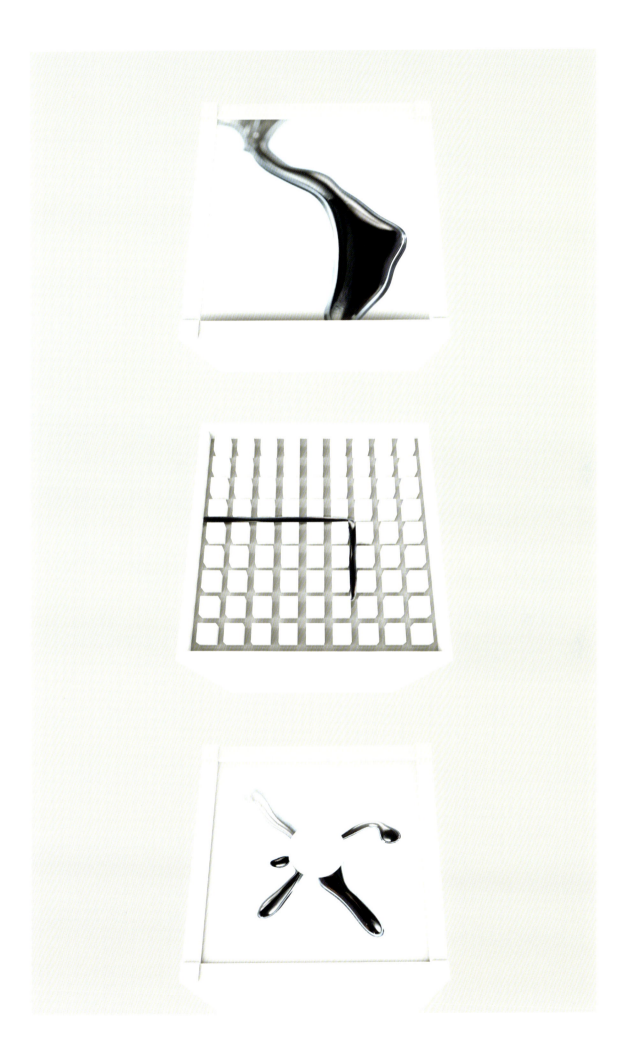

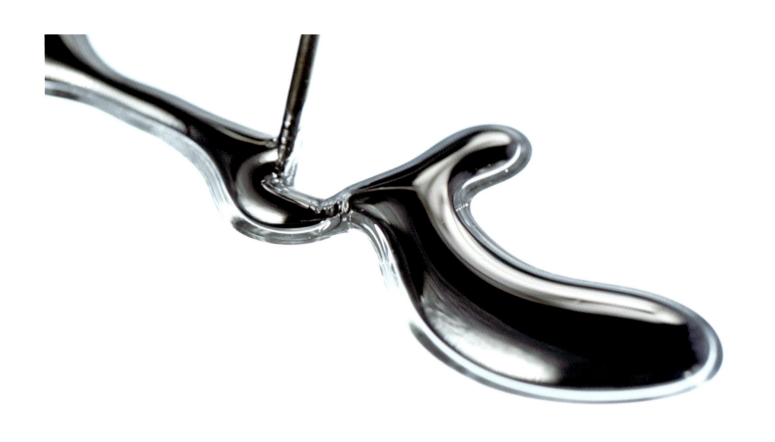
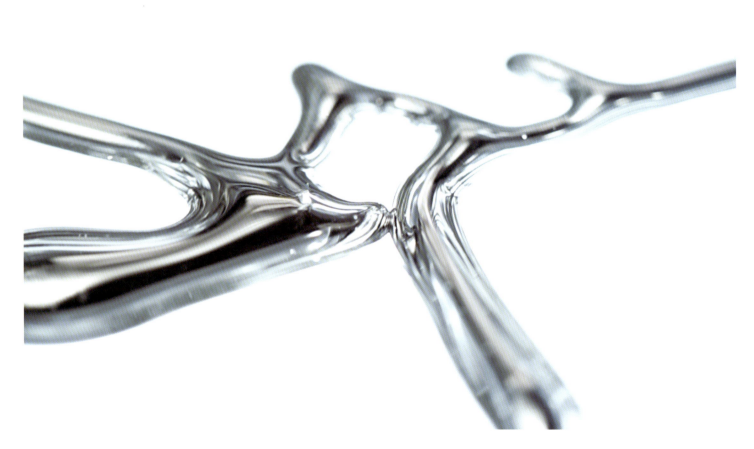

生态与人居
ECOLOGY AND HUMAN SETTLEMENT

参数化建造——米兰世博中国馆 /
PARAMETRIC CONSTRUCTION-
CHINA PAVILION IN MILAN EXPO

民居的变迁 /
TRANSORMATION OF RESIDENCE

垂直村落 /
THE VERTICAL VILLAGE

南极大陆：再循环 /
ANTARCTICA: RECYCLE

通天沙塔 /
SAND BABLE

欲望城市——花 /
THE CITY OF DESIRE-FLOWER SERIES

我脸上的雾霾PM2.5 /
THE HAZE PM2.5 ON MY FACE

参数化建造——米兰世博会中国馆
PARAMETRIC CONSTRUCTION-CHINA PAVILION IN MILAN EXPO

清华大学美术学院米兰世博会项目组、建筑设计：陆轶辰（中国）/
THE GROUP OF MILAN EXPO, ACADEMY OF ARTS & DESIGN, TSINGHUA UNIVERSITY, ARCHITECTURE: LU YICHEN (CHINA)

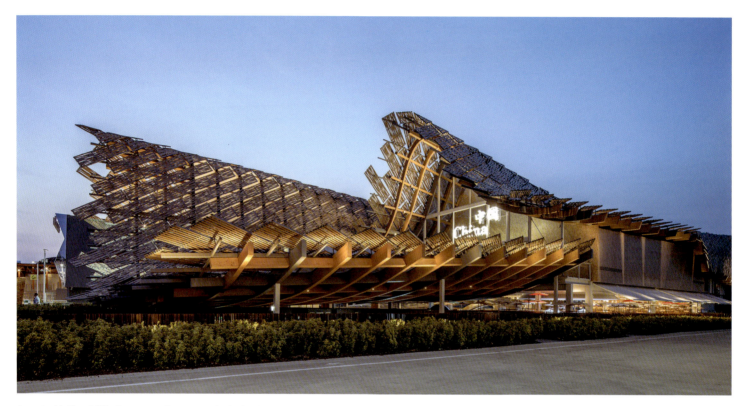

新一届的世界博览会于2015年5月1日在意大利米兰召开。此届米兰世博会中国馆是中国首次以独立自建馆的形式赴海外建馆参展。作为中国当代建筑与世界的一次对话，中国馆的设计在艺术之美中蕴含着重要的技术创新：

1. 创造性地采用了以胶合木结构、PVC防水层和竹编遮阳板组成的三明治开放性建构体系，以实现轻盈的屋面并满足大跨度的内部展览要求；

2. 采用胶合木结构来实现大跨度的展览空间，真实地呈现建构节点和木构件，成为中国传统建筑文化的一个当代表达；

3. 由电脑参数化"写"出来的1059块屋面参数化遮阳竹瓦，在PVC表皮上布下的斑驳投影，表达了属于中国的空间品质。从参数化到建造的过程，都体现了米兰世博会中国馆项目的实验性与先锋性。

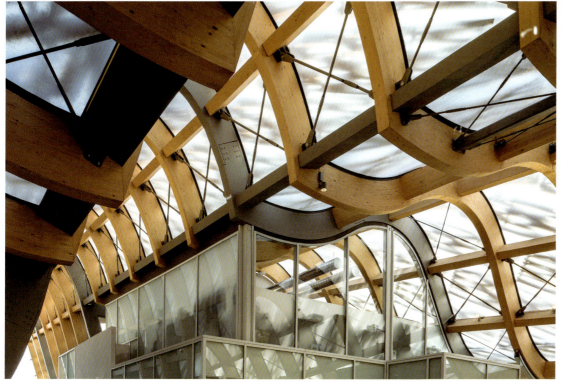

创作年代 / Date
2013-2015

The latest World Expo was held in Milan, Italy in May 1, 2015. China Pavilion in this session of the World Expo Milan is the first time to built overseas pavilion independently. As to dialogue between Chinese contemporary architecture with the world, the design of China Pavilion contains important technological innovation in the beauty of art: first of all, to realize the light of the roof and to meet the requirements of the large span of internal Exhibition, the pavilion adopt the creative use of sandwich open system construction, consisting of laminated wood structure, PVC waterproof layer and bamboo shade; secondly, the use of laminated wood structure to achieve a large span of exhibition space, presenting the real construction nodes and wood components, which is a contemporary expression of Chinese traditional architectural culture; thirdly, the 1059 shading bamboo components of the curved house roof, scripted by the parametric program in computer, when dappled sunlight shone through the shades, it make a new expression of Chinese spatial quality. From the process of parameteric design to the construction fufillment, it represent the experimental and avant-garde of the China Pavilion project.

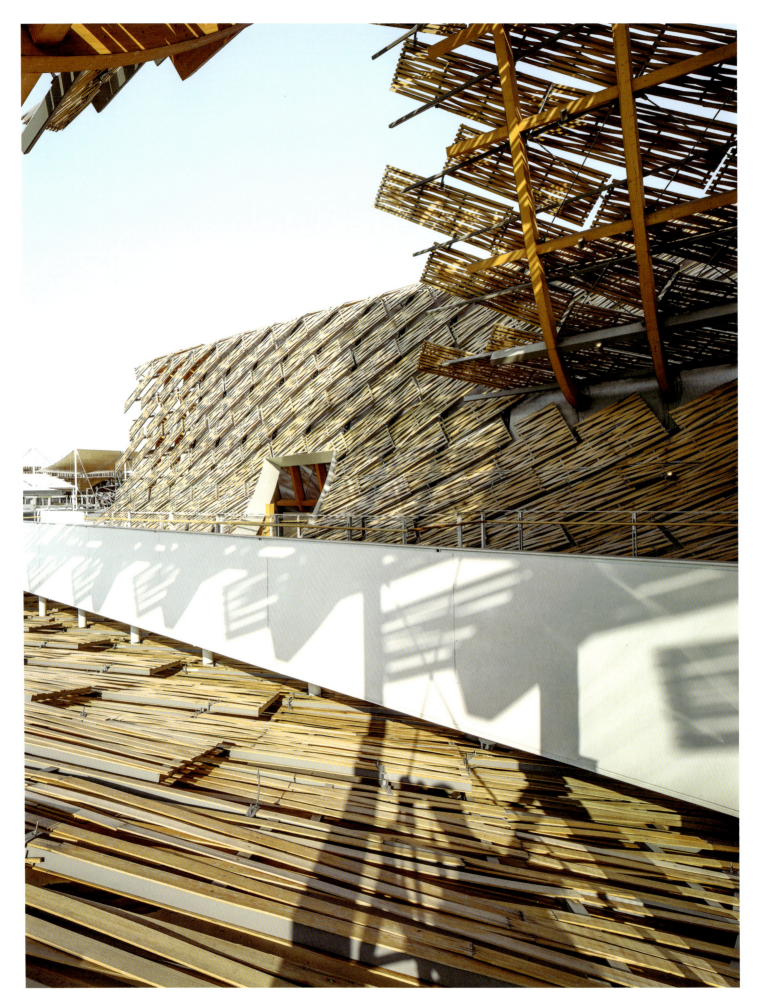

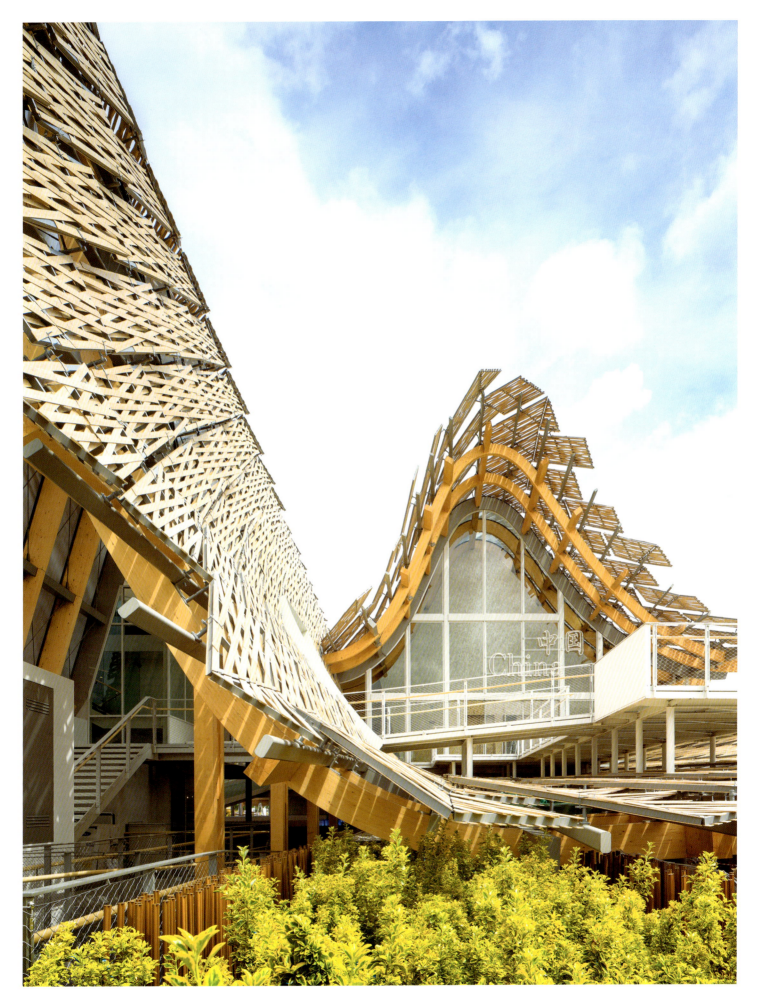

民居的变迁 / TRANSORMATION OF RESIDENCE

谢英轩（中国）/ XIE YINGXUAN (CHINA)

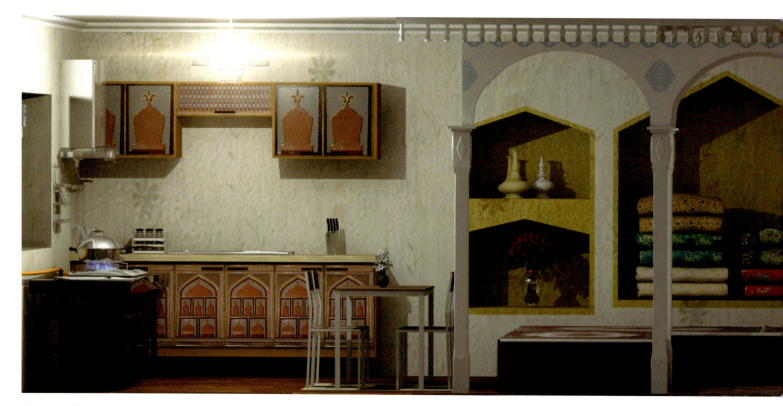

作品运用数字新媒体4D解构和虚拟现实技术，展示一个少数民族家庭从新疆和平解放前到现在，不同年代家居环境的变迁，以点带面，生动地展示60年来，新疆各族人民生活发生的巨大变化，特别是中央新疆工作座谈会以来，自治区实施安居富民等一系列民生工程，带给各族群众实实在在的好处。

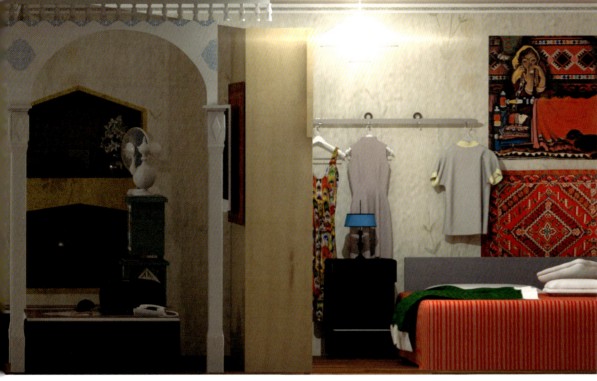

创作年代 / Date	2015
材质 / Material	综合材料，影像 / Mixed Media, Video
尺寸 / Dimension (cm) 长×宽×高 / Length×Width×Height	240cm×75cm×54cm

Using new 4D deconstruction and virtual reality technology, this art work show a Xinjiang minority family's living condition before the peaceful liberation to the present. This individual family's living condition improvement is mapping the whole picture of all ethnic groups' condition in Xinjiang, vividly exemplify the civil engineering and series economic policies bring tangible benefit and great changes to the people in all ethnic groups in Xingjiang, especially after Central Xingjiang Symposium held in Beijing .

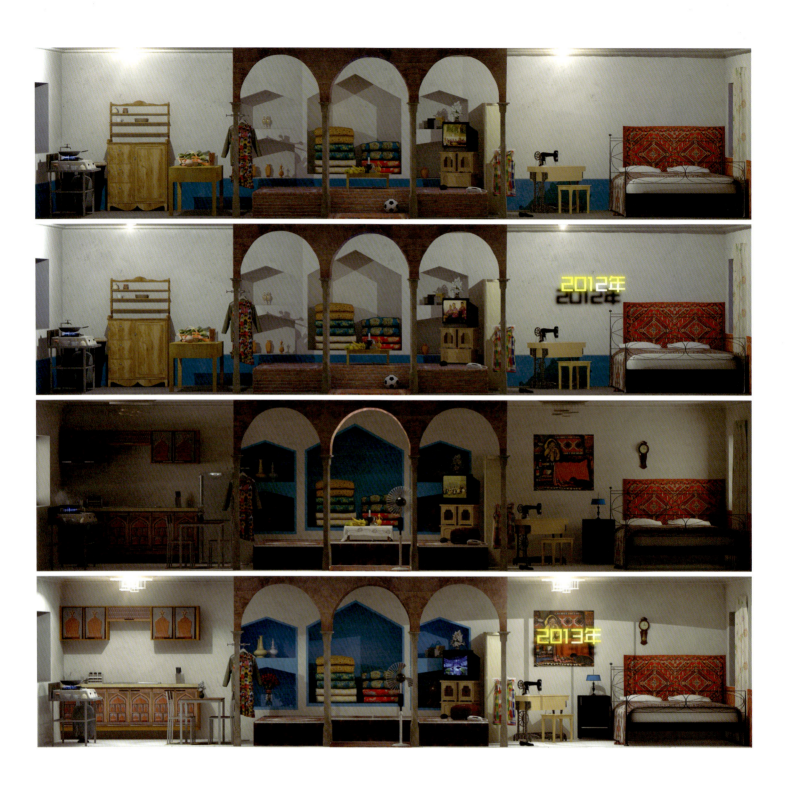

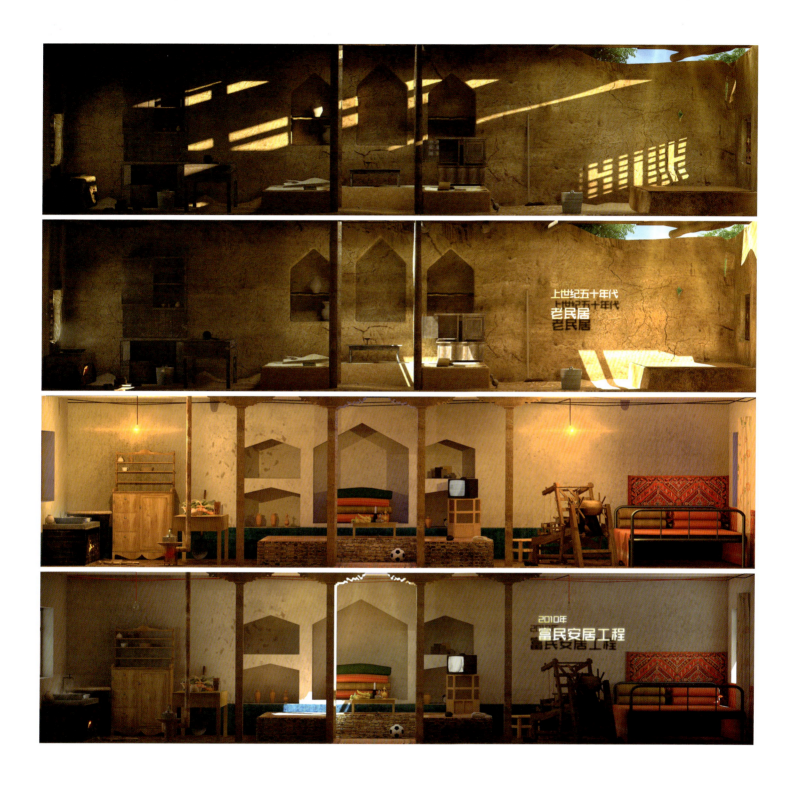

垂直村落 / THE VERTICAL VILLAGE
MVRDV（荷兰）/ MVRDV (HOLLAND)

"垂直村落"在探讨一种进化的都市学，既响应了亚洲城市的高密度需求，也提倡了非正规空间成长，在提供社区生活弹性的同时，也捍卫了居住者的个人自由。

数百年来，东亚城市的纹理是由都市村落形成的。小型的、非正规的，往往是"轻质的"建筑物构成了这些都市村落，它们形成社交来往紧密频繁的社区，而强烈的个体性与差异性仍得以维持。从第二个千禧年开始以后，这些城市在人口成长与经济力量的驱使下快速地改变，那些已有好几百年历史的都市村落被秋风扫落叶般刮个干净。外来的建筑带来了西方标准的生活，却也在此过程中彻底摧毁本土的小区形态。

"垂直村落"是将都市村落垂直化地成长，让拥有露台与屋顶花园且适合休闲活动的住宅类型得以出现。这种舒适的生活方式甚至连中产阶级与上层阶级都能为其吸引，进而引领更加综合与更不具隔离性的社会。住宅可以和小型办公室、工作室结合。与群楼不同的是，这新形态的村落能让建立在个人表现与突显个性的建筑得以存在。设计提供一个可行的模式让都市建筑自行组织建构，能随着时间成长、缩减与随时间改变，就像历史的城市村落那样。这种模式能够孕育出垂直的村落，一个三向度的小区，将个人自由、多样性与邻里生活等，带回亚洲，甚至西方的城市。

创作年代 / Date
2013

材质 / Material
视频 / Videos

时长 / Running Time
4:05

The Vertical Village is probing an evolving urbanism which is to response the high-density demand of Asian cities and to allow the growing of informal spaces. It could retain individual freedom of residents while providing flexibility in the community.

For centuries, the fabric of East Asian cities has been formed by urban villages that are built up of small scale, informal, often "light" architecture. These urban villages form intense, socially connected communities where strong individual identities and differences are maintained. Driven by demographic and economic forces since the start of the second millennium, these cities are rapidly changing. In a relentless 'Block Attack', invading – scraping away the urban villages that have evolved over hundreds of years. These alien buildings provide a Western standard of living, destroying indigenous communities in the process.

"Vertical Village" is to allow the Urban villages of vertical grouth, let have a terrace and roof garden and suitable for the residential type to appear. This approach could enable housing types with terraces and roof gardens that accommodate leisure activities. This comfortable lifestyle might even attract the middle and upper classes, leading to a more mixed and less segregated society. Homes could even be combined with small - scale offices and workspaces. In contrast to the blocks, this new village type might enable an architecture based on individual expression and identity. Design a workable model for a self-organized process of city building, the model can grow and shrink and change in time – as historic urban villages did. The model can generate a vertical village – a three-dimensional community that brings personal freedom, diversity, flexibility and neighborhood life back into Asian, and maybe even Western cities.

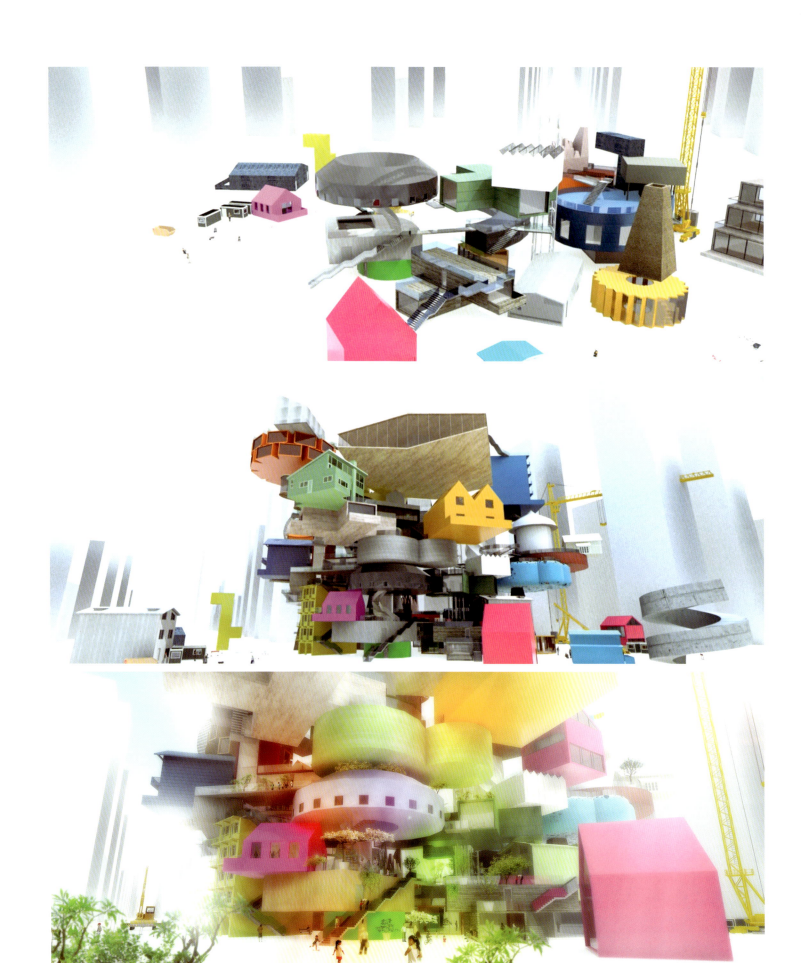

南极大陆：再循环 / ANTARCTICA: RECYCLE

哈尼·拉什德工作室（美国）& 维也纳应用艺术大学（奥地利）/
STUDIO HANI RASHID (USA) & UNIVERSITY OF APPLIED ARTS VIENNA (AUSTRIA)

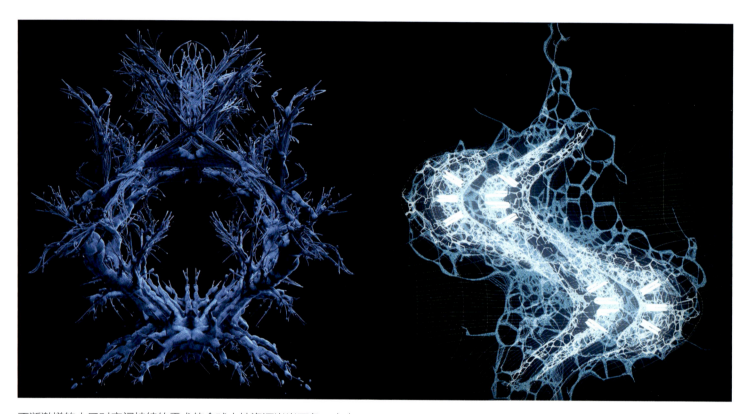

不断激增的人口对空间持续的需求使全球土地资源岌岌可危，未来的南极大陆，是一个带有各种可能性的契机，更是一片充满挑战与未知的土地。而厄尔尼诺现象和温室效应将对南极带来戏剧化的影响：预测在21世纪末，这片渗透着神秘力量的土地将适合大量人口的居住，其气候与温度会像今天的北斯堪的纳维亚地区一样"适宜"，甚至有一天这里还会有农作物出现。我们作为建筑师或规划者，如何在这个具有现实意义的预言的基础上进一步探究其实质？如何使这遍布冰雪的特殊地貌在发展的过程中兼具前瞻性和合理性？

哈尼·拉什德工作室在维也纳应用艺术大学创建的"遥远未来工作室"回答了这一系列假设，他们通过全息装置生动地描述了南极大陆的城市、社区、建筑在21世纪晚期的形成与演变。作品由七个方案组成：游牧之城、食物生产区、生态系统之城、能源收发站、生物站、冬奥会竞赛场、环球服务器之城——数字神庙。

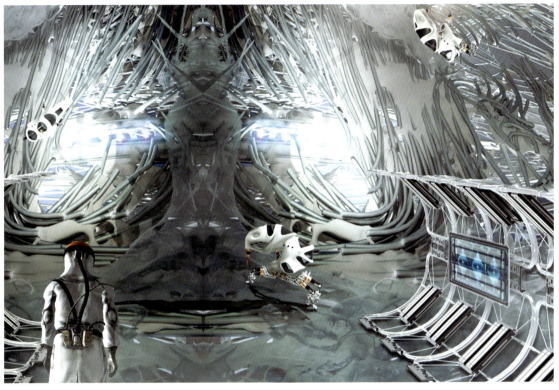

创作年代 / Date
2016

材质 / Material
图片、视频 /
Pictures, Videos

尺寸 / Dimension (cm)
长×宽 / Length×Width
60cm×80cm

Mankind's continuous and relentless need for space is unavoidable and a key factor in anticipating what the future of the planet holds. In particular, a closer look at the future of Antarctica is now more critical than it has ever been. The Antarctic is a powerful place of remarkable beauty and perfection. With global warming and rising sea levels, this precious place will undoubtedly be impacted. By many accounts, the earth's climate will change so dramatically over the next 100 years that the weather systems and temperatures we today consider "normal" in places such as northern Scandinavia could very well be the norm in certain parts of Antarctica, making it inhabitable by large populations possibly by the end of this century. The notion that Antarctica could one day see crop production alone begs the question of how we as architects and planners might consider such a strangely reconfigured global future. As there is increasingly a plausibility to such a future where these extraordinary terrains of snow and ice might be massively overtaken out of necessity, we today need to confront some serious questions as to how we might grapple with such an impending and stark reality.

Studio Hani Rashid at the University of Applied Arts Vienna, Deep Future Lab will exhibit a number of visionary architectural proposals focused on the prospect of building new types and formations of communities for the late 21st century and beyond. Works by seven programs: city nomadic, food production apeas, urban ecosystem, the energy transceiver station, biological station, winter Olympics field, the city of universal server-Digital Temple.

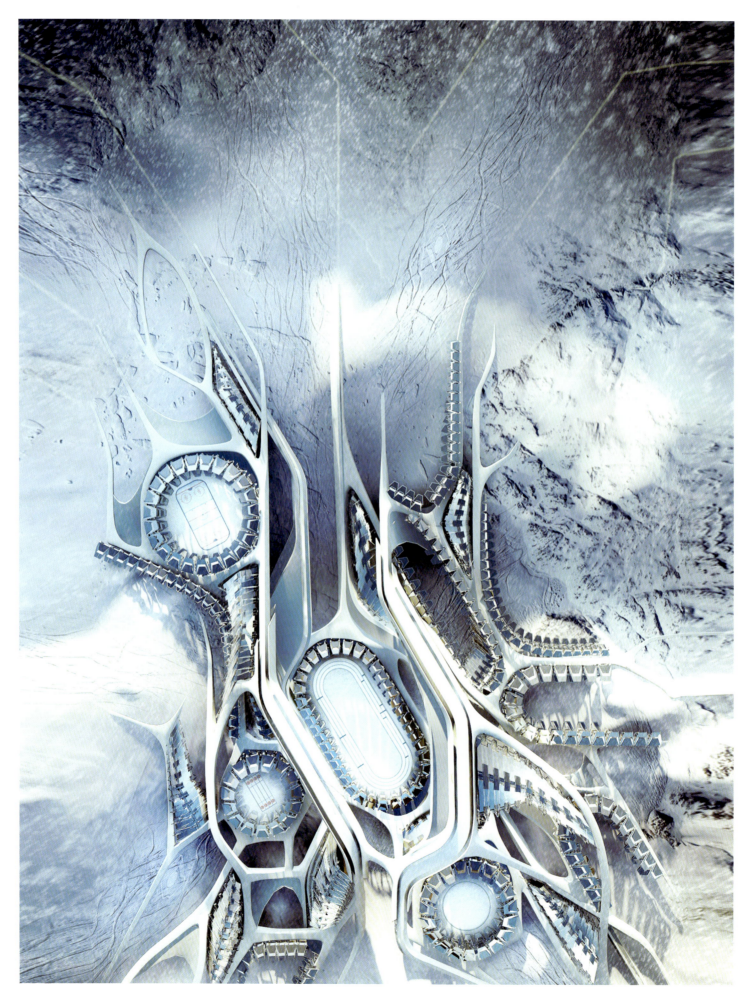

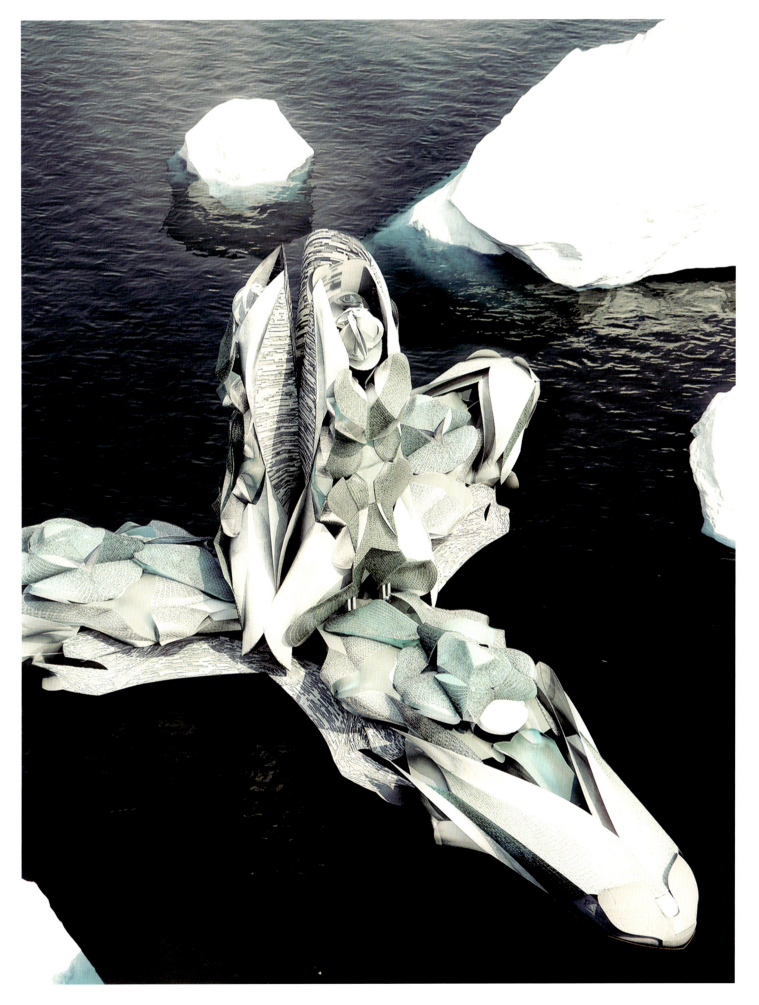

通天沙塔 / SAND BABLE

邱松（中国）/ QIU SONG (CHINA)

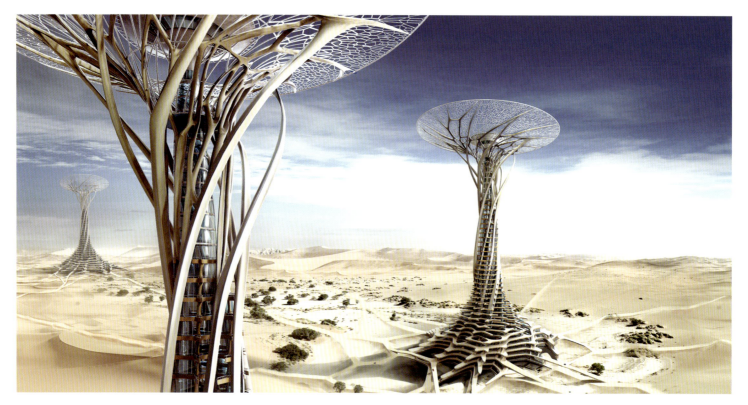

"通天沙塔"建于广袤的沙漠之中，是一个可供科学考察和休闲观光的生态建筑群。"建筑群"可划分为两个部分，地上部分由众多独立的建筑单体构筑，形成了错落有致的"沙漠社区"；地下和地表部分由建筑群相互连接，形成了多种功能的"管网系统"。每栋建筑的主体部分，均通过太阳能3D打印技术将沙子烧结后构筑而成。地上部分的建筑造型源于沙漠中"龙卷风"和"风蚀蘑菇"的形态，造型采用了多组螺旋骨架结构，挺拔而颇具张力感，主要用来满足人们居住、观光和科考等功能。"双漏斗"造型不仅有利于建筑内部的空气对流，而且还能利用地表与高空的温差效应在建筑顶部形成冷凝水，待汇集后为建筑提供宝贵的水源。建筑的地下及地表部分造型呈网状结构，宛如树的根系，一方面有助于固定"流动"的沙丘，帮助建筑"生根"；另一方面又能为建筑间的沟通提供便利。

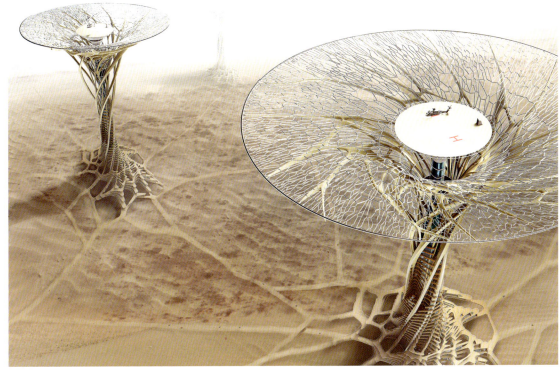

创作年代 / Date
2014

材质 / Material
喷绘展板 / Printing Pannel

尺寸 / Dimension (cm)
长×宽 / Length×Width
100cm×90cm
90cm×90cm
120cm×90cm

Sand Babel, which is a group of ecological structures, is built in the vastness of desert, serves the purposes of both scientific inquiry and sightseeing. The structures are divided into two parts. The first part is above ground part that consists of many independent structures and forms a well-proportioned Desert Community. The other part is underground and surface, which is connected by buildings, and creates a multi-functional tube network system. The main portion of each building is constructed with sand sintered through a solar-powered 3D printer. The form of the aboveground structures are designed based on nature phenomena of desert called Tornadoes and Mushroom Rocks. It utilizes a spiral skeleton structure, which is tall, straight and with strong tension, to meet the requirements of residential, sightseeing and scientific research. The Dual Funnel Model not only improves cross-ventilation inside, but also generates condensation water at the top of structures based on the temperature difference between ground and above higher. Then the collected condensation water supplies the Sand Babel. The net structure for the portion of underground and surface is similar to tree roots. This design not only helps to fix flowing sand dunes in place such as structures is rooted, but also facilitates communication among the buildings.

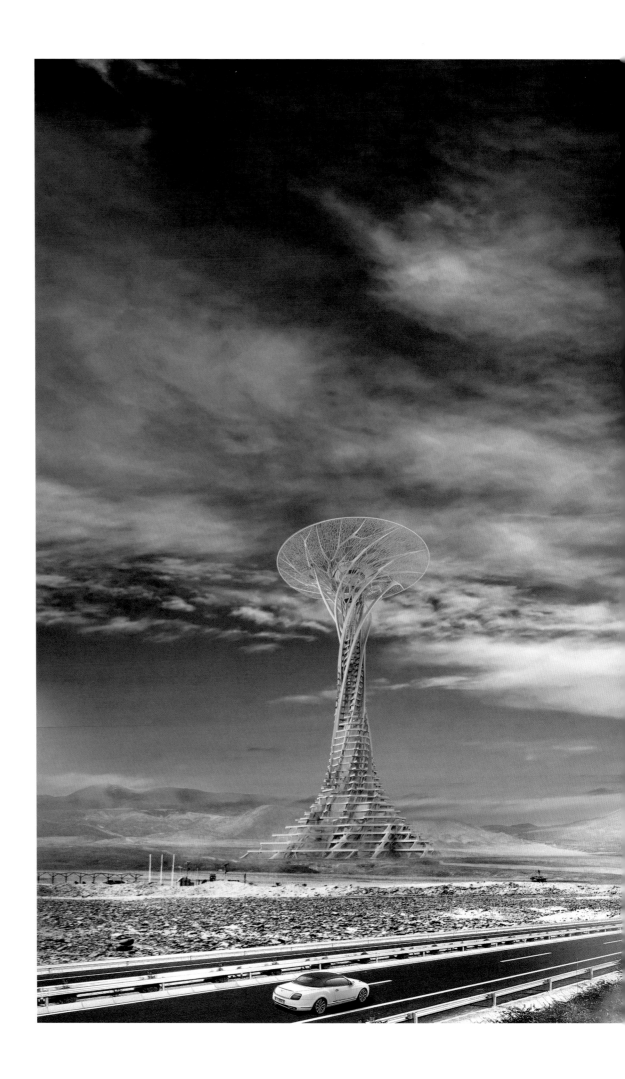

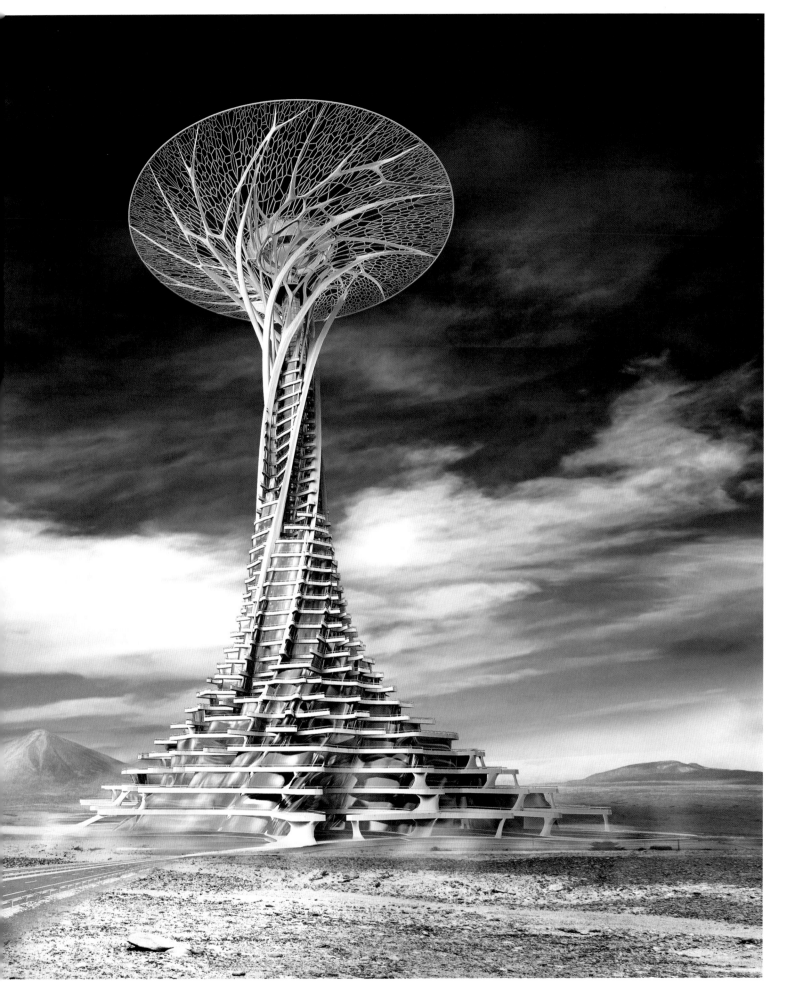

欲望城市——花 / THE CITY OF DESIRE-FLOWER SERIES

陈辉（中国）/ CHEN HUI (CHINA)

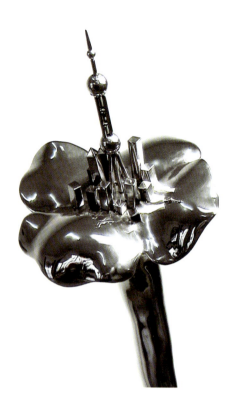

创作年代 / Date
2010

材质 / Material
不锈钢 / Steel

尺寸 / Dimension (cm)
长×宽×高 / Length×Width×Height
200cm×100cm×100cm

我们每天生活在城市之中，一方面惊叹城市的光鲜炫目，享受其带来的便利，另一面城市也带来了我们现代人的种种忧虑，譬如水危机、空气污染、能源危机等。人创造了城市这个集合了人类智慧精华的东西，它深深地影响着你的一切，你却与它是那么的陌生，让你无法了解亲近。作品表现人的欲望被雄伟的城市不断催化膨胀，被欲望包裹的城市犹如鲜花一样绽放这一主题。

We live in the city every day, on the one hand we are fascinating the glitz and glamour of the amazing city, enjoying its convenience; on the other hand the city has brought us all sorts of worries, for example, water crisis, air pollution, energy crisis, and etc... People created the city which collect the essence of human wisdom, it deeply affects all of you, but it is acting like a stranger to you, so you can not understand it closely. The art work is to express the desire of people is catalyzed by the majestic city's continuous expansion, the city is being wrapped by the desire of people and blooming like a flower.

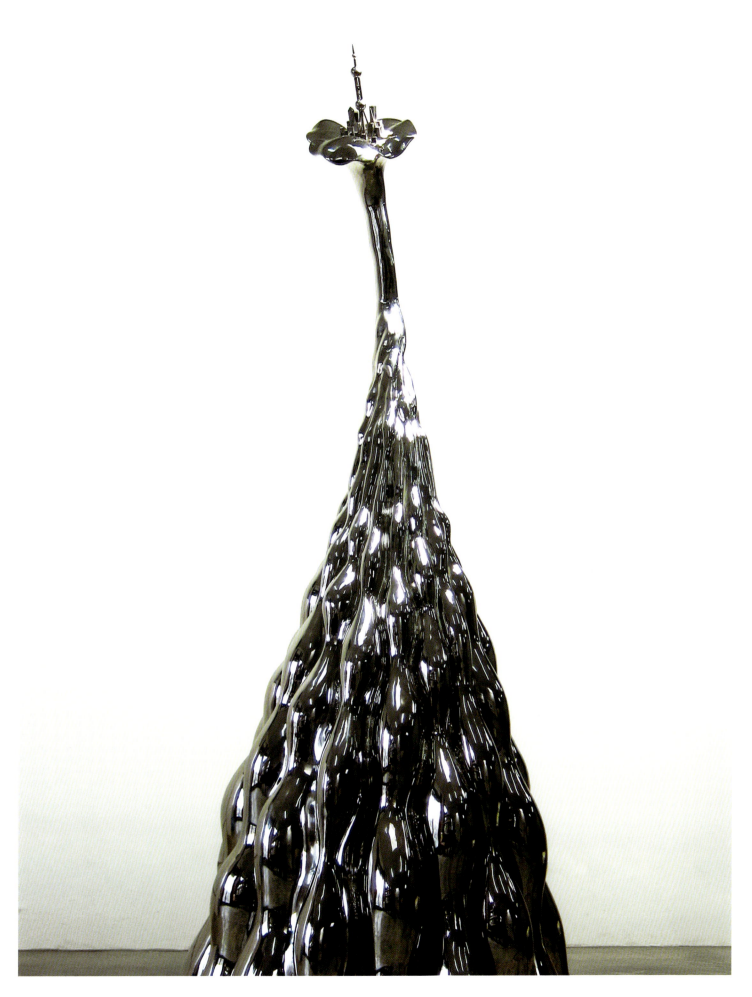

我脸上的雾霾PM2.5 / THE HAZE PM2.5 ON MY FACE

李天元（中国）/ LI TIANYUAN (CHINA)

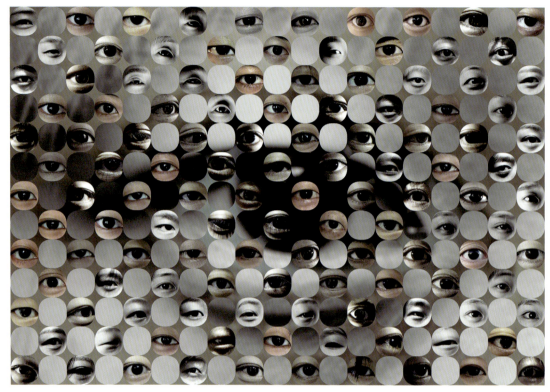

创作年代 / Date
2016

材质 / Material
艺术微喷 / Art micro spray

尺寸 / Dimension (cm)
长×宽 / Length×Width
256cm×110cm

作品展示了从李天元脸上取下的雾霾PM2.5微粒，并用"汇拍"软件自动生成的作品，表现了作者在北京12个小时内雾霾微粒附着在脸上的多样的真实形态。

The work show PM2.5 haze particles taken from Li Tiannyuan's face. Application of "Meeting shoot" software automatically generates works. Performance of the author in Beijing 12 hours haze particles adhered to the face of a variety of true form.

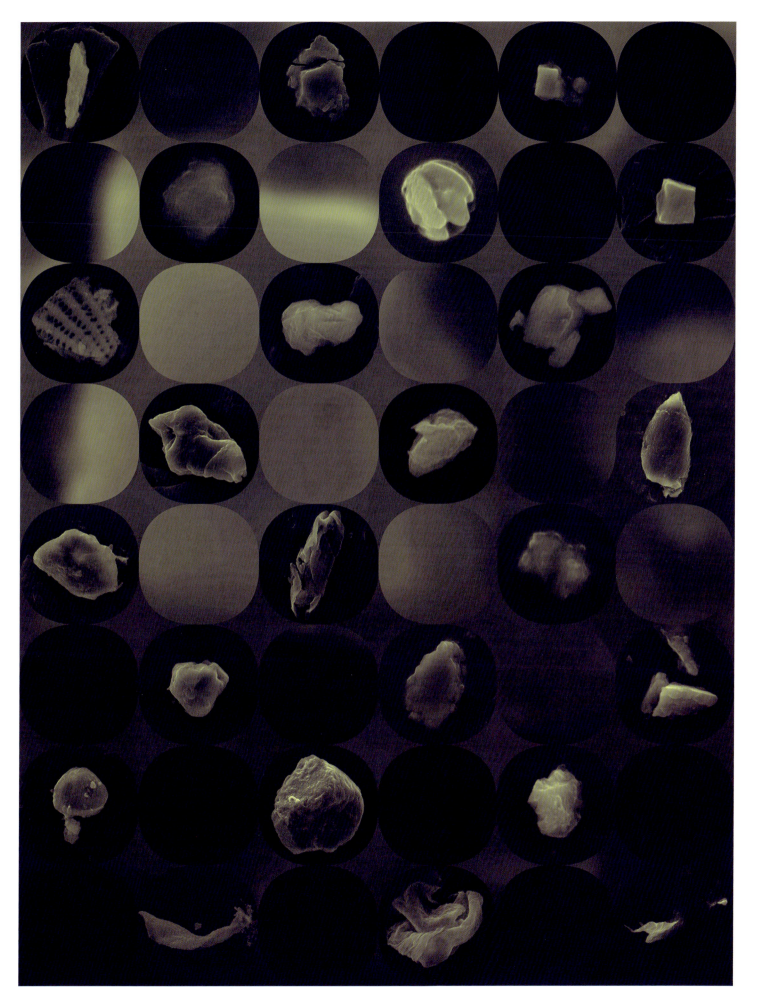

信息与智能
INFORMATION AND INTELLIGENCE

律动的城市 /
RHYTHMIC CITY

树的灵感 /
THE IDEA OF A TREE

魔镜 /
MAGIC MIRROR

韩熙载夜宴图交互长卷 /
INTERACTIVE SCROLL - HANXIZAI

遇唐·敦煌（敦煌虚拟现实展示）/
ENCOUNTER WITH THE TANG DYNASTY, DUNHUANG (DUNHUANG – VR EXHIBITION)

阿凡达变形记 /
MORPH MIRROR

隐藏的机械舞者 /
THE INVISIBLE

律动的城市 / RHYTHMIC CITY

吴琼（中国）/ WU QIONG (CHINA)

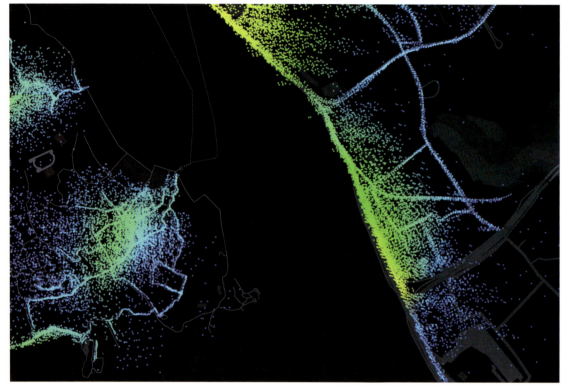

创作年代 / Date
2016

材质 / Material
视频 / Videos

作品是厦门居民出行大数据的可视化。作品通过将厦门市民每天不同时间的出行位置、方向、距离等数据的实时渲染，描述了厦门市民的出行地点、目的地，出行需要的时长和总体规律，绘制出一幅实时的、动态的厦门城市居民的流动过程，反映出厦门的区域布局、空间联系等城市特征。城市出行大数据可视化所描述的图景如同律动的城市脉搏，让人们可以从另一个角度来观察、分析自己所熟知的城市，其中的规律和特征也为快速发展的城市提供了交通和城市规划布局的重要依据。

The work was a data visualization of Xiamen residents' trip. The work visualized real-time data of Xiamen residents' trip on various periods of the day, such as positions, directions and distances. Those visualizations described Xiamen residents' points of departure, destinations, duration and general rules, rendered a real-time mobility map and dynamic flow of Xiamen city residents, and reflected the sections distribution and connection characteristic of the city. The landscape described by the data visualization looked like rhythmic pulses of the city, by which people can observe and analysis their familiar city from another perspective, the rules and characteristics of which are available for transport and urban planning of the rapid developing city.

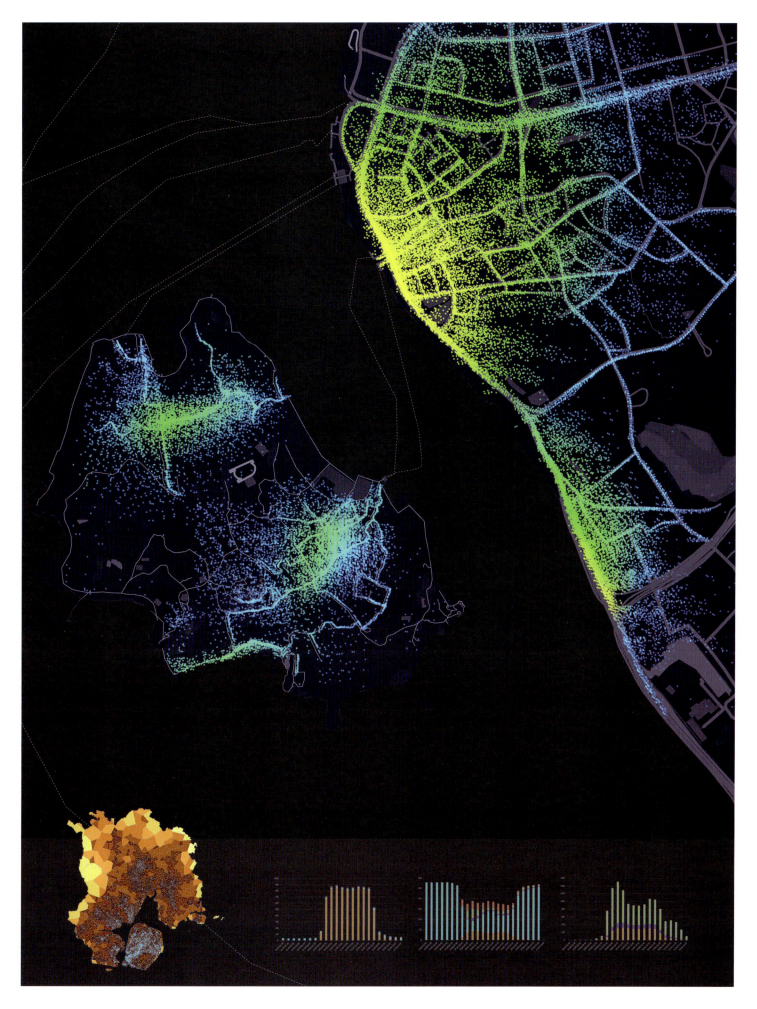

树的灵感 / THE IDEA OF A TREE

卡塔琳娜·米舍尔 & 托马斯·特拉克斯勒（奥地利）/ KATHARINA MISCHER & THOMAS TRAXLER(AUSTRIA)

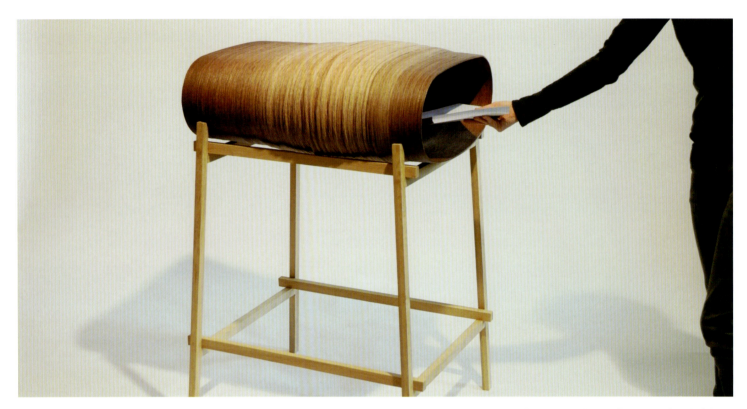

"树的灵感"是一种天然材料与机械流程相结合的自主生产过程。这一过程采用太阳能来驱动，每天通过一套机械装置将太阳光的强度转换成一件物品。它的产品反映了当天不同的日光条件。就如一棵树一样，这件物品成了它自己创生的过程与时间的三维记录。

作品中的"一号记录器"从日出时开始生产，到红日西沉时便停工。日落之后就可以"收获"完工的物品了。它慢慢地"生长"物品，通过一台上色装置和一缕从胶水槽抽出的纱线，最终把它们绕在一只模子上。产品的长度和高度取决于当天日照的时间。卷绕每一层的厚度与颜色则取决于太阳能的多少（日光越多，绕层越厚、颜色越淡；日光越少，绕层越薄、颜色越深）。

这过程不仅对不同的天气条件作出反应，而且还对紧邻机器的周边环境中出现的阴影作出反应。每一朵云彩、每一道阴影对成品的外观都有重要的影响。该设计可以生产出多种物品。

将天然要素引入系列生产的这种观念，提出了审视区位的新视角。这种"工业区位"，所重视的并不是地方文化、手工艺或资源，而是生产过程周围的气候要素和环境要素。你能从这设计所产生的不同物品上，分辨出它们的生产地点。例如，在赤道上物品的高度/长度始终都一样，而在北欧和中欧，季节变化对物品的形状就会产生不同的影响。在雨水丰沛的国家里，物品的颜色更深、绕层更薄；而在阳光明媚的地区，物品颜色更淡、绕层更厚。对于我们而言，"树的灵感"是从理想主义的角度，来看机械如何与自然相结合，生产出更了不起的成果——在自然的韵律之中沐浴日光、从事生产的工业场所。

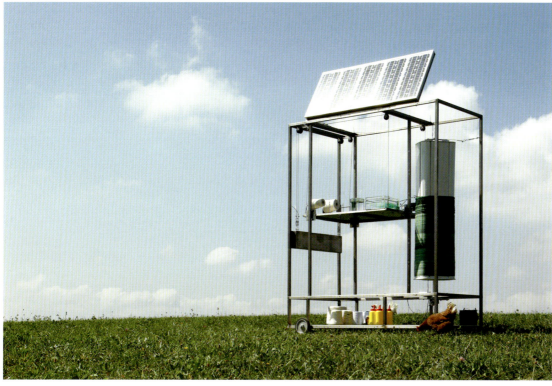

创作年代 / Date
2008

材质 / Material
树脂、棉线、橡木、色彩 /
Resin, Cotton Thread, Oak, Color

尺寸 / Dimension (cm)
长×宽×高 / Length×Width×Height
凳子 / Chair: 80cm×52cm×50cm
灯罩 / Lamp: 60cm×60cm×30cm
容器 / Container: 30cm×30cm×45cm

"The idea of a tree" is an autonomous production process which combines natural input with a mechanical process. It is driven by solar energy and translates the intensity of the sun through a mechanical apparatus into one object a day. The outcome reflects the various sunshine conditions that occur during this day. Like a tree the object becomes a three dimensional recording of its process and time of creation.

The machine "Recorder One" starts producing when the sun rises and stops when the sun settles down. After sunset, the finished object can be 'harvested'. It slowly grows the object, by pulling threads through a colouring device, a glue basin and finally winding them around a mould. The length/height of the resulting object depends on the sun hours of the day. The thickness of the layer and the colour is depending on the amount of sun-energy. (More sun = thicker layer and paler colour; less sun=thinner layer and darker colour)

The process is not just reacting on different weather situations, but also on shadows happening in the machine's direct surrounding. Each cloud and each shadow becomes important for the look of the final object. Various the 'idea of a tree' - objects are possible.

The concept of introducing natural input into a serial production process suggests a new way of looking at locality. This "Industrialized Locality", is not so much about local culture, craftsmanship or resources, instead it deals with climatic and environmental factors of the process' surrounding. On a series of objects you can tell somehow the place of production. On the equator, for example, the objects would always have the same height/length, whilst in North- and Middle Europe, the seasons help shaping the objects. In countries with a lot of rain the objects would be darker and thinner whilst in sunnier regions the objects would be paler but thicker. For us "The idea of a Tree" is an idealistic vision on how machines combined with nature can produce great results, - an idea of industrial halls with daylight and manufacturing within natural rhythms.

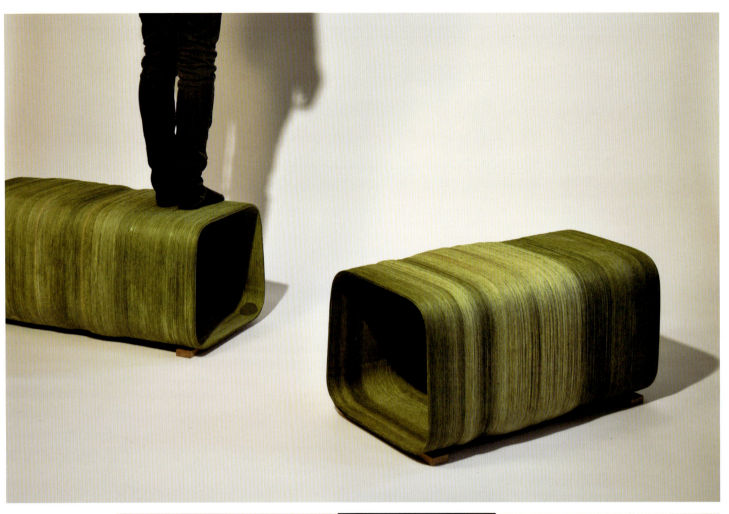
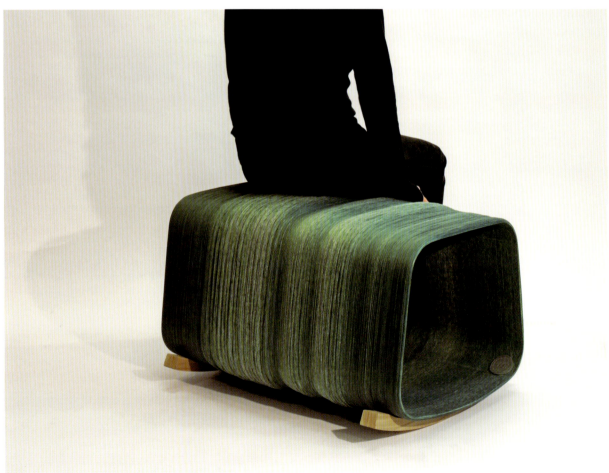

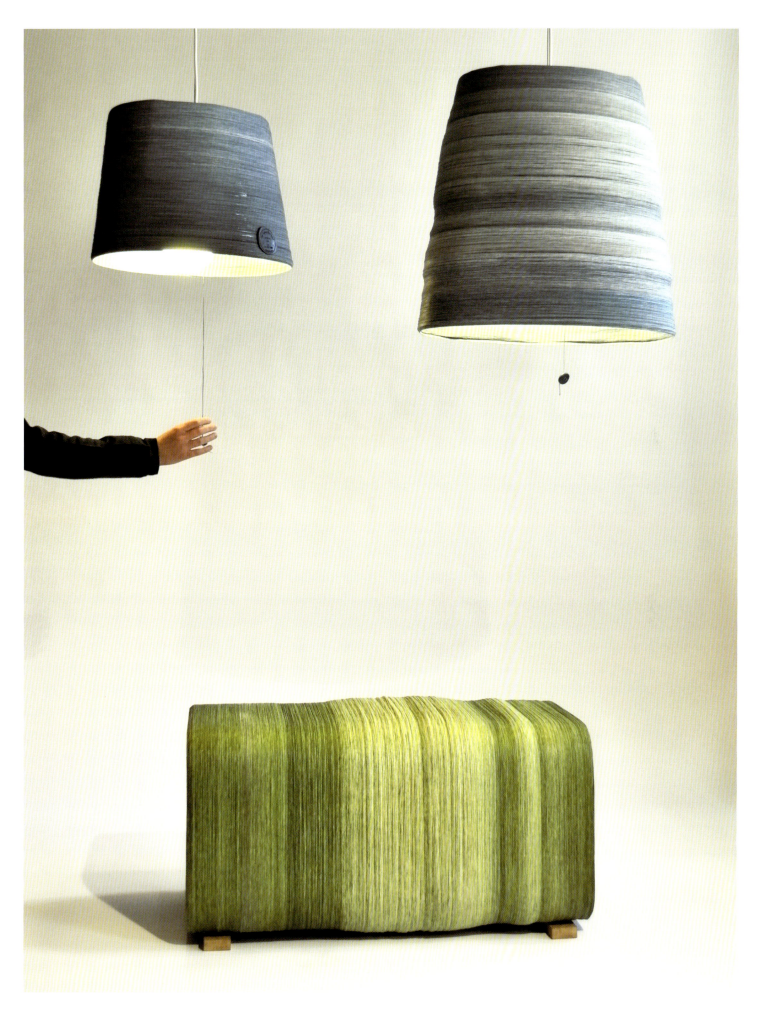

魔镜 / MAGIC MIRROR
王之纲（中国） / WANG ZHIGANG (CHINA)

创作年代 / Date
2016

材质 / Material
交互影像装置 /
Interaction Video Installation

尺寸 / Dimension (cm)
长×宽×高 / Length×Width×Height
400cm×275cm×295cm

虚幻和真实在我们生活的数字时代重新被不同的方式定义和解读。镜子一直都是一种神秘的媒介，既可映照自身，又可打开通往另一个世界的大门，将虚幻和现实融为一体。通过这个作品，观众看到镜子中的自己仿佛进入一个神奇的世界，一些顽皮的、害羞的精灵会聚集在观众周围并有灵性的与观众互动，让观众沉浸在虚幻和现实的奇妙转换之中。

Illusion as well as reality are re-defined and comprehended by different ways in the digital age we live in. Mirror is always a mysterious medium, it not only can shine upon itself, but also open the door to another world, and integrate the fantasy and reality. Through this work, the audience can see himself in the mirror as if enter into a magical world where some naughty and shy fairies gather around the audience and make a spiritual interaction with them. Then ,the audience will be immersed in the wonderful conversion between imagination and reality.

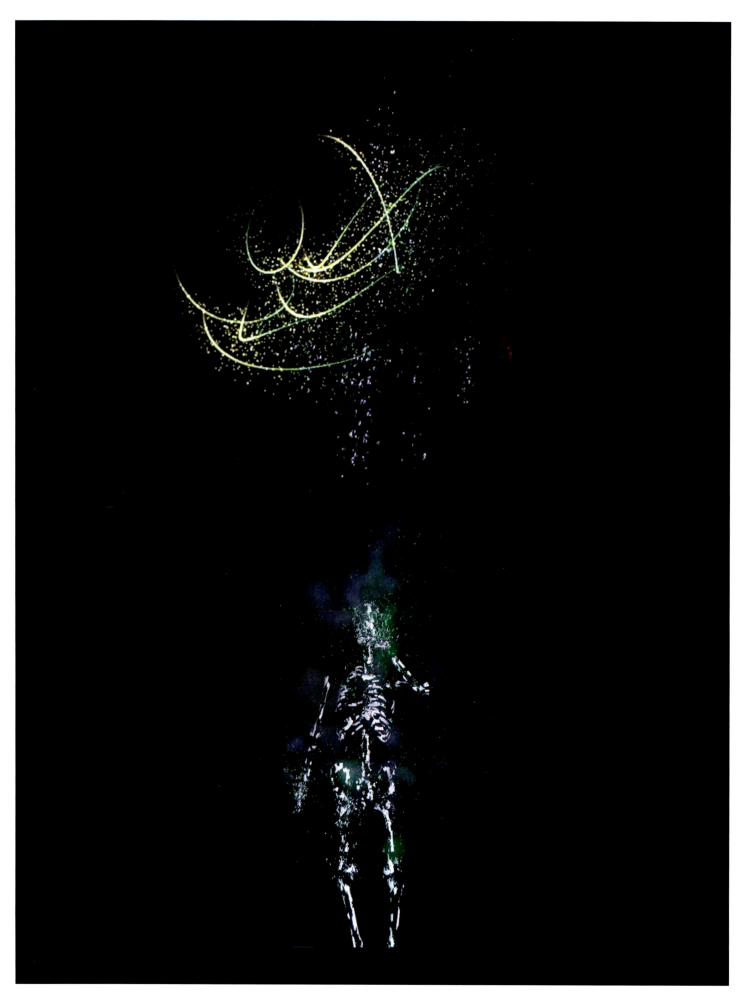

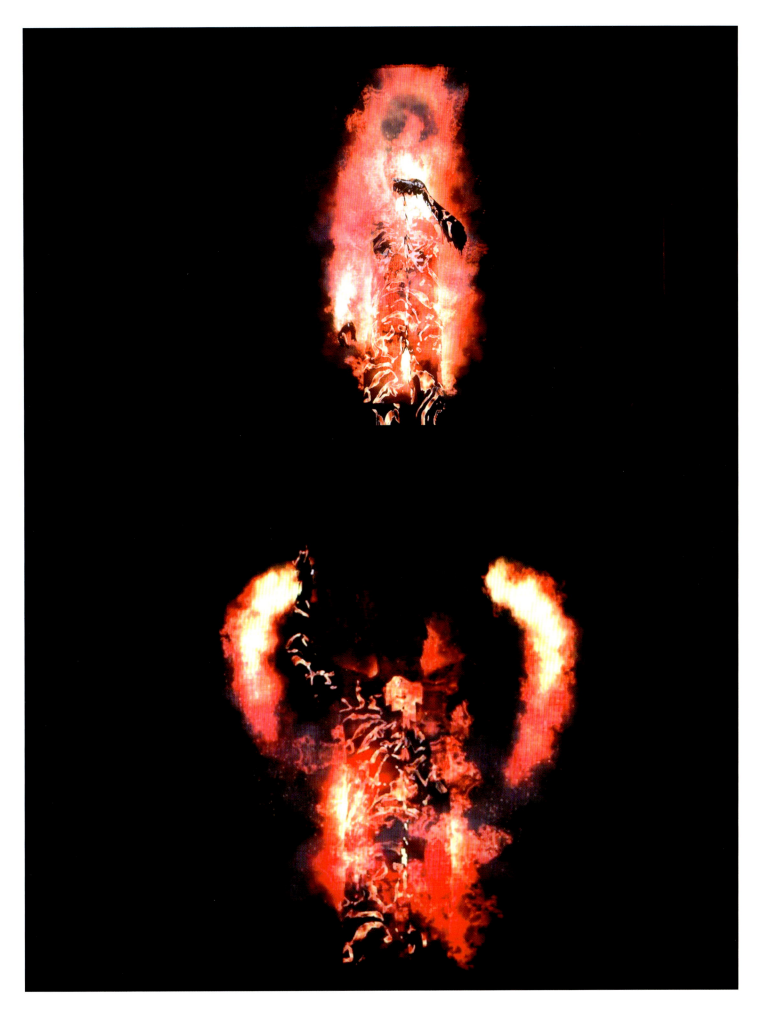

韩熙载夜宴图交互长卷 / INTERACTIVE SCROLL - HANXIZAI

师丹青、史清源、陈聪鑫、冯爽妮（中国）/ SHI DANQING, SHI QINGYUAN, CHEN CONGXIN, FENG SHUANGNI(CHINA)

创作年代 / Date
2016

材质 / Material
影像、互动程序 /
Video, Interactive Program

尺寸 / Dimension (cm)
长×宽×高 / Length×Width×Height
2个55寸电视窄边拼接屏 /
2×55 Inches TV Connected in Width

该作品为中国著名古代书画作品《韩熙载夜宴图》的数字交互版本，《韩熙载夜宴图》是中国古代著名书画，又是叙事长卷的典型代表，全卷按韩熙载府上所举办夜宴的情景顺序分为五段。作为中国历史上著名的"连环叙事"式书画长卷，画卷中所体现出的故事性以及历史性更具吸引力。本作品利用新媒体手段重新演绎《韩熙载夜宴图》，根据画面特点对画面和画卷的情节进行了交互设计、叙事设计、动画设计、三维场景再现。通过观众与画卷的互动，启发观众理解韩熙载夜宴图背后耐人寻味的历史故事，感受中国书画文化的魅力。

装置由200cm×50cm大的电子屏幕以及长180cm的模型台、长180cm的灯光控制台构成，电子屏幕用来逐场播放韩熙载夜宴图的画面，灯光控制台通过控制五个不同的灯光来控制屏幕中的画面播放，聆听画面所表现的故事。模型台上放置了立体化的韩熙载夜宴图，通过观众对立体化韩熙载夜宴图的观察，辅助观众理解画面的空间关系。

The activity of viewers within a certain range of space will get response on painting. Handle prop is the equal of medium between viewers and spacial interface. Considered with the style of Chinese ancient times, the shape of handle prop is designed as a candle. Viewers use electric candle to interactive with digital painting.

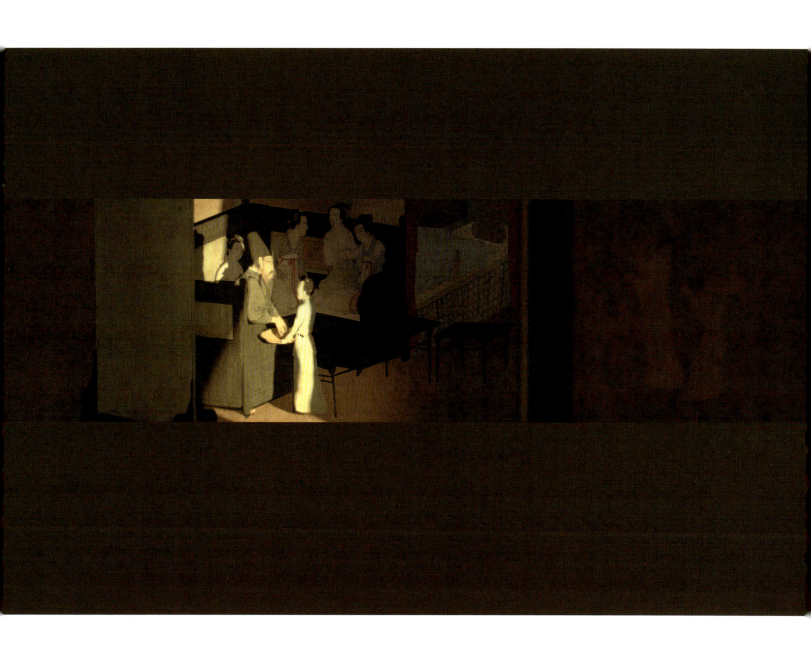

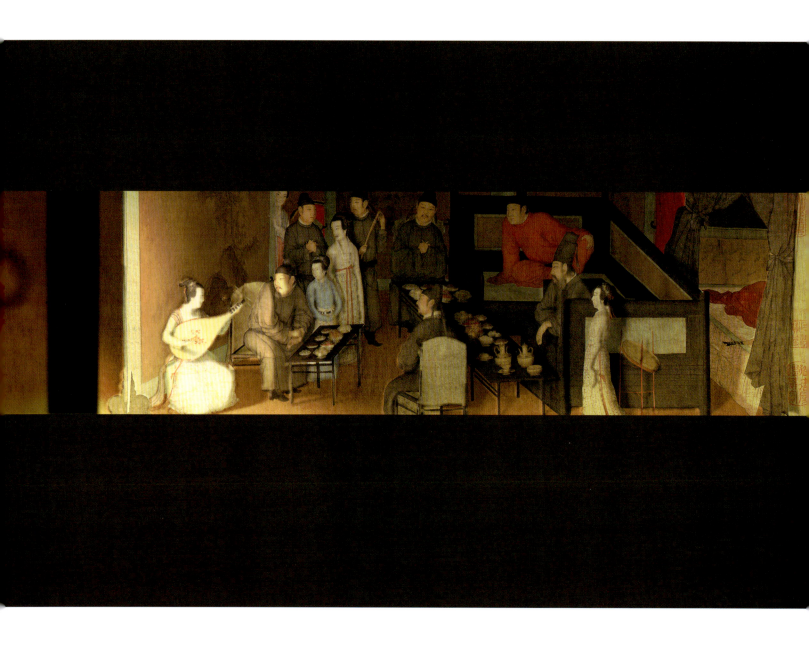

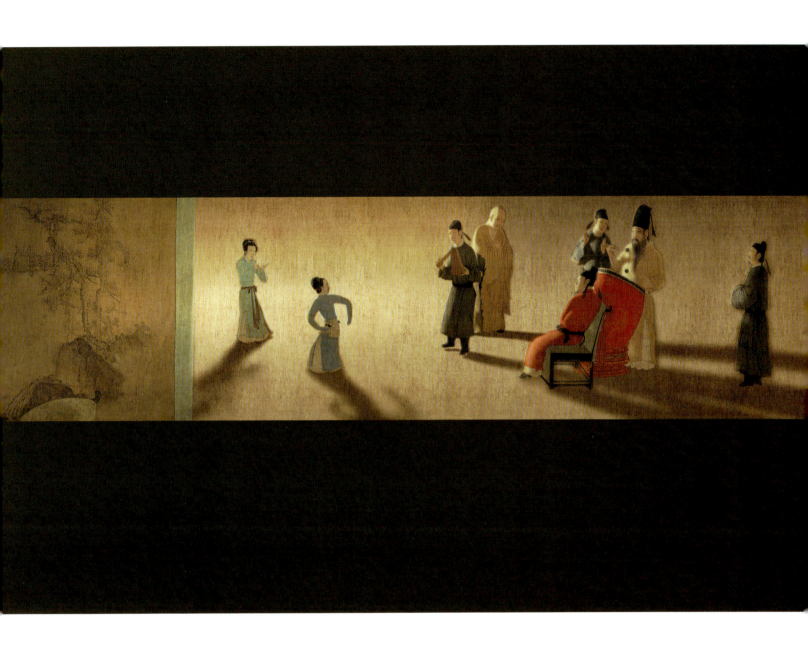

遇唐 · 敦煌（敦煌虚拟现实展示）/
ENCOUNTER WITH THE TANG DYNASTY, DUNHUANG (DUNHUANG – VR EXHIBITION)

鲁晓波、马立军（中国）/ LU XIAOBO, MA LIJUN (CHINA)

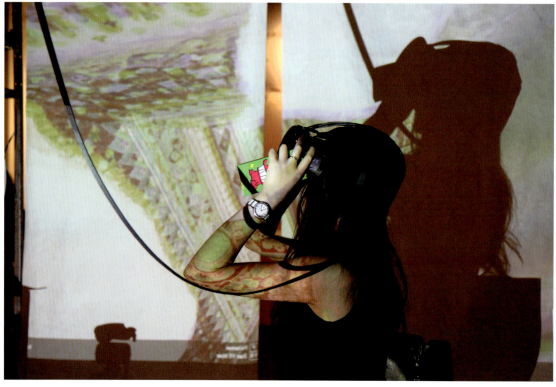

创作年代 / Date
2016

材质 / Material
VR装置、互动影像 /
VR Installation, Interactive Video

尺寸 / Dimension (cm)
长×宽×高 / Length×Width×Height
空间 / Space: 400cm×360cm×295cm
投影 / Projector: 400cm×225cm

该作品作为敦煌数字化保护虚拟展示平台的一部分，是基于莫高窟第159窟的现状构建的高精度虚拟洞窟。莫高窟第159窟为中唐年间吐蕃占领敦煌时期当地民众开凿，为中小型洞窟。本作品以虚拟现实的方式让观众从现实世界瞬间移步进入莫高窟第159号洞窟的现场。体验者可在其中行走与观看洞窟内雕塑与壁画细节，带来身临其境的感受，作品呈现了写实的现场视觉还原和超现实的数字修复效果科学可视化，增加了观众对石窟体验深度。

This work is part of a VR platform for the presentation of the digitized cultural heritage of Dunhuang, a Buddhist center on the ancient Silk Road famous for its cave temple. It is based on a high-definition virtual reconstruction of the current state of Cave 159 of the Buddhist Mogao Grottoes of Dunhuang. This work employs VR methods to put the presentation visitor right into the middle of this cave. The visitor can move about freely and, in an impressive immersive experience, get close-up looks at the details of the sculptures and murals inside.

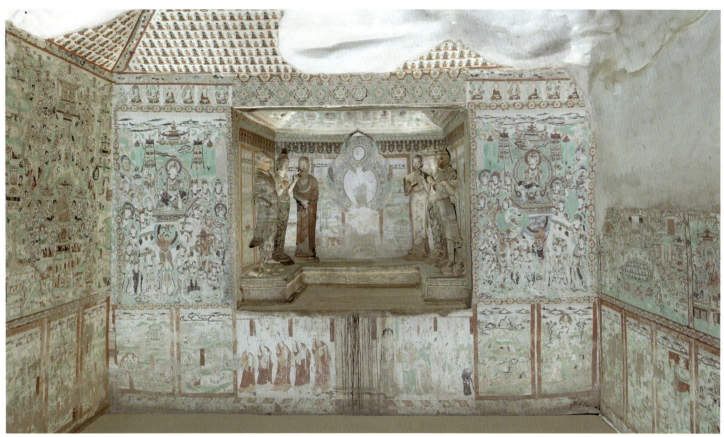

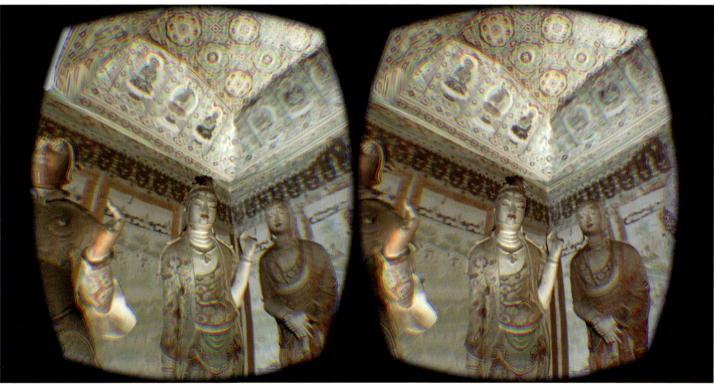

阿凡达变形记 / MORPH MIRROR
师丹青（中国） / SHI DANQING (CHINA)

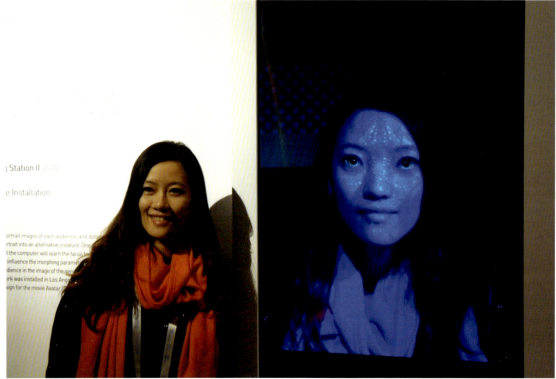

创作年代 / Date
2009

材质 / Material
互动影像 /
Interative Video

尺寸 / Dimension (cm)
长×宽×高 / Length×Width×Height
电视 / TV：55英寸 / 55 Inches

作品利用人脸识别技术以及计算机图形算法，将面向作品观众的肖像捕捉下，并实时地进行五官拉伸变形，"异化"成为一个似像非像的外星化身。该作品，曾作为20世纪福克斯公司电影《阿凡达》的交互式广告，在美国纽约、洛杉矶等地推广。

With facial recognition and graphic algorithm technology, this work captures audience's face, and morphs it into an alien's face. This work was commissioned by 20 Century Fox Studio for its movie Avatar, as an interactive advertising and promotion in New York, Los Angeles and other places.

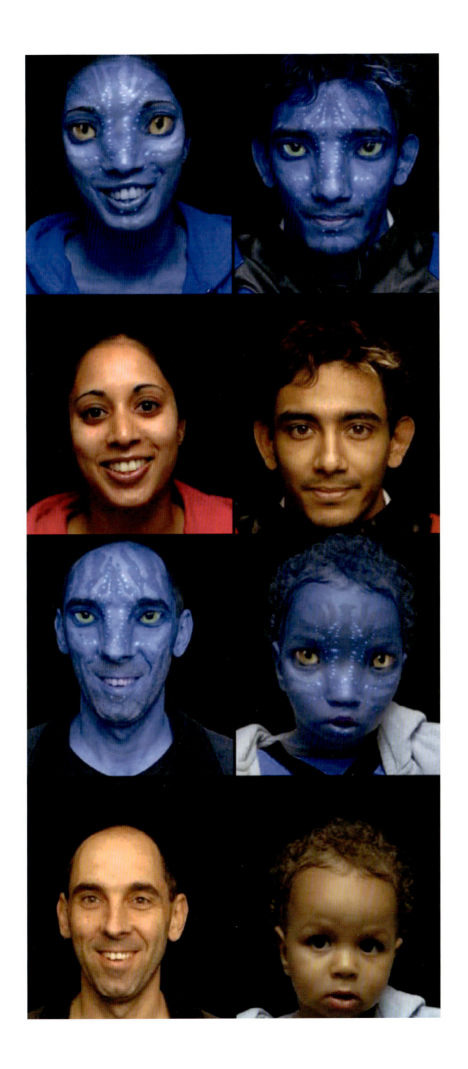

隐藏的机械舞者 / THE INVISIBLE
皮特·威廉·霍顿（英国）/ PETER WILLIAM HOLDEN (UK)

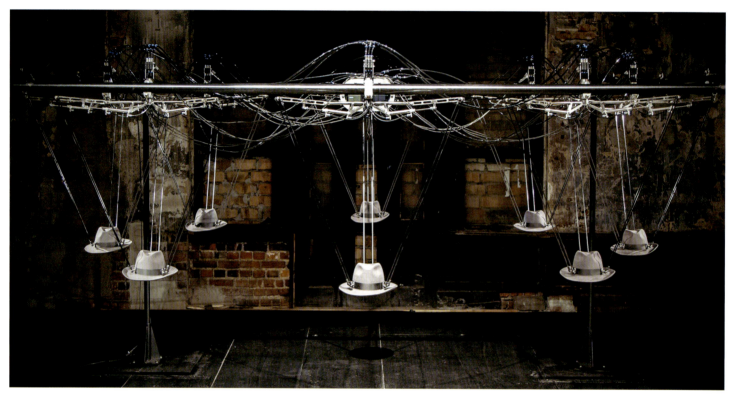

"隐藏的机械舞者"是一项我追踪数年所做的主题连续调查中的一部分。这项调查是为了发现摄影和雕塑之间界限被消融的方式，由此而来的是我寻找到捕捉和保存动态的替代方法。为了实现此目的，我已经探索到机械化物理对象与计算机设备相结合的可能性，以及如何将它们运用于制作动画，使之存在于超出屏幕之外，而又兼具触觉和时限性的特质。

"隐藏的机械舞者"作为雕塑的表现形态而呈现，它是由八个复制的定制的机器人所组成，这些机器人均已停摆，且均匀地排列成圆形图案，在金属框架内。Fedora的帽子通过许多黑色的棒子来附在每个机器人元素上，以便这些帽子从观察者的视觉上粗略感觉是悬在半空中的。这种安排暗指每个帽子的下面都直接有一个隐形人的存在，对人类而言这样的影射是我作品中一个共同特征。电缆和空气管需要充足的数量，这点可以合并到机械元素中去。这样一来就可以在计算机编程的指导下，让标志性的Fedora的帽子动起来，操作这些帽子，使它们可以表演编排的舞蹈/动画。这就导致帽子在形状构成上需急转弯，它们还要旋转和俯冲，并伴有女武神中瓦格纳（德国歌剧家）的骑马声，以一种超现实戏剧的敬礼方式致敬电影现代启示录。

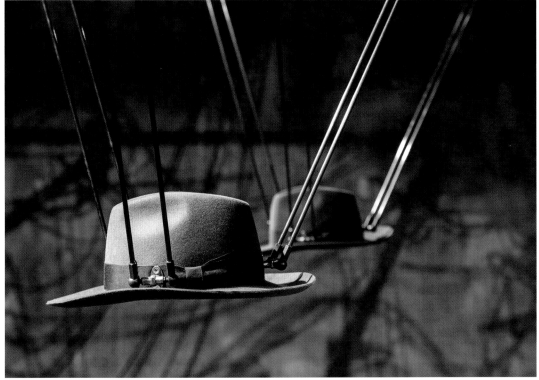

创作年代 / Date
2015

材质 / Material
帽子，钢，电脑，定制机器人，压缩空气组件，MP3 /
Hats, Steel, Computer, Custom Built Robots, Compressed Air Components, MP3 Player.

尺寸 / Dimension (cm)
长×宽×高 / Length×Width ×Height
500cm × 500cm × 250cm

"The Invisible" is part of a continued investigation of a theme I've been pursuing over numerous years. A search to discover ways of dissolving the boundaries between cinematography and sculpture, and thus find alternative ways to capture and preserve motion. To accomplish this, I've been exploring the possibilities of mechanized physical objects combined with computational devices and how they can be applied to make animations which exist beyond the screen that are both tactile and time-based.

"The Invisible" is presented as a sculptural performance that is comprised of eight duplicate custom built robots all suspended and arranged evenly in a circular pattern from a metal frame. Fedora hats are attached via a multitude of black rods to each robotic element so that the hats hang in midair at roughly eye level with the observer. This arrangement alludes to an invisible human presence directly below each hat and this allusion to humanity is a common feature in my work. A copiousness number of electrical cables and air tubes are joined to these mechanized elements. Which allows under the guidance of a computer program the movements of the iconic Fedora hats to be manipulated and enables the piece to perform a choreographed dance / animation. Resulting in the hats swerving in formation, gyrating and rushing this way and that to the accompanying sound of Wagner's Ride of the Valkyries in a surreal theatrical homage to the film Apocalypse Now.

自然与生命
NATURE AND LIFE

超以像外 /
BEYOND GENERAL RELATIVITY

自问自答 /
SELF Q AND A

无限的限制 /
THE INVISIBLE HAS LIMITS

诗意书写在自然 /
POETIC WRITING FOR NATURE

神经元·创造，神经元·生长 /
GENESIS, THE GROWING NEURON

翔 /
FLYING

上上下下左左右右 /
UP UP DOWN DOWN, LEFT LEFT RIGHT RIGHT

超以像外 / BEYOND GENERAL RELATIVITY

鲁晓波（中国）/ LU XIAOBO (CHINA)

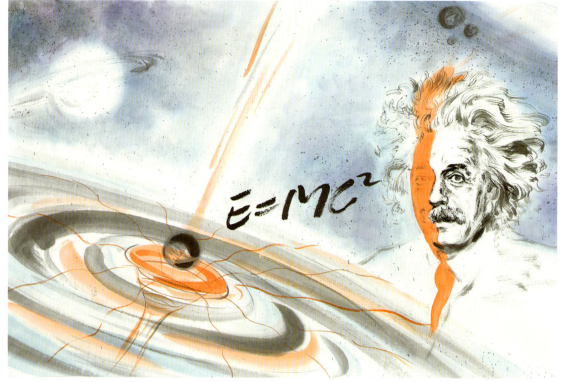

创作年代 / Date
2016

材质 / Material
宣纸水墨 / Ink and Paper

2015年是爱因斯坦划时代的杰作"广义相对论"发表的一百周年。广义相对论用简洁的几何语言描写引力，颠覆了人们的时空观，并让人们震惊于这种自然界基本力量的美丽。

而基于广义相对论发展起来的现代宇宙学，更是让我们深入认识了所处宇宙的发展历史。在这一百年的时间里面，科学家是如何推进对引力的认识的？质量如何让时空弯曲？引力波是什么？宇宙将向何处去？这些问题都引人深思。该作品展示了爱因斯坦和广义相对论的宇宙，向世人传递科学与艺术交融的美妙意境。

2015 is the one hundred year anniversary of the publication of Einstein's "general relativity". The theory of general relativity stress in a concise geometric language to describe the gravity, subverting the people's view of space and time, so that people are shocked by the beauty of the basic power of nature.

Modern cosmology are developed based on the theory of general relativity, which let us deeply understand the history of the development of the universe. In this one hundred years of time, how do scientists advance the understanding of gravity? How quality bend the time and space? What is gravitational waves? Where does the universe go? These questions are thought-provoking. This work shows the universe of Einstein and his theory of general relativity, in order to convey the world that its really beauty if science mingle with art.

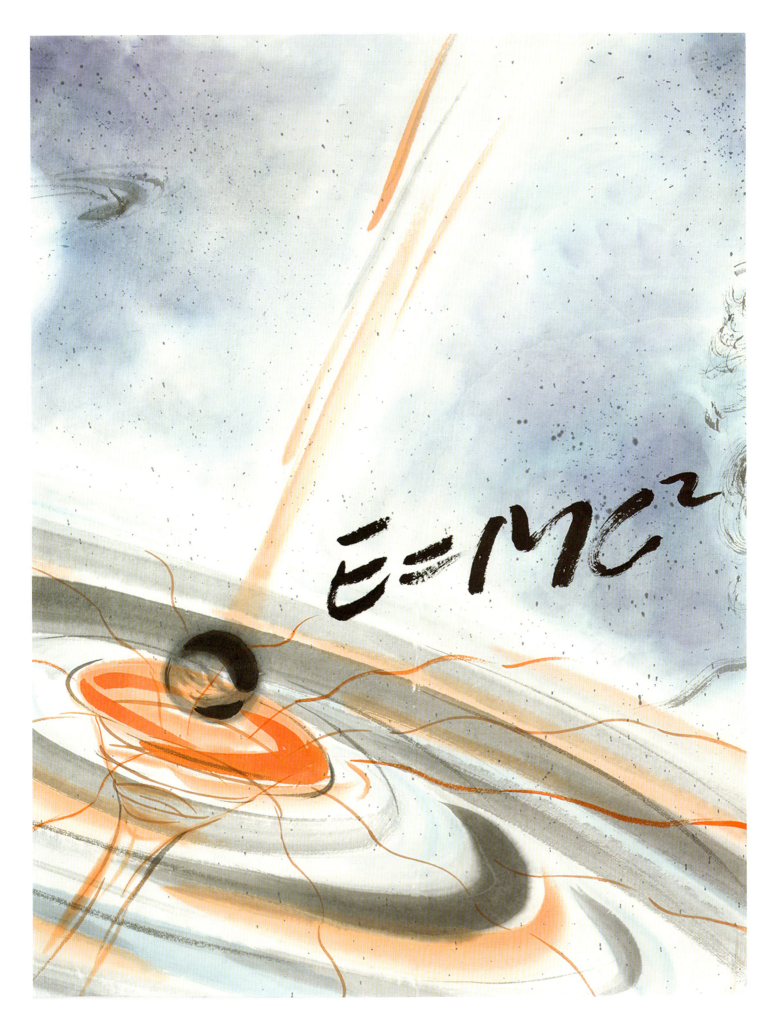

自问自答 / SELF Q AND A

彦风、吴帆（中国）／ YAN FENG , WU FAN (CHINA)

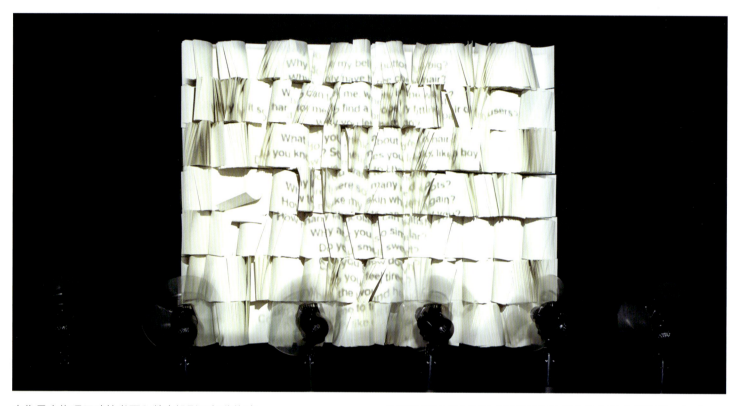

本作品由物理互动的书页和数字投影两部分构成。

作品分别从物理的互动角度以及语言的概念角度来探讨"问题"与"答案"的关系并以此隐喻现象。视频投影文本内容来自于懵懂儿童的随机天真的提问，且只有问题而无答案。通过这样一种看似荒谬的问题搜集与呈现，来探测人类思维的边界和轮廓，同时也借此隐喻当代现实世界的人类处境。问题既是探寻世界的开始也构成了人类知识的一种形式。

以充满各种天真问题文字投影作为问题，以空无一物的书籍发出的声响作为回应，并以投影、声音、运动的物理互动形式在展览空间中呈现了一部乌托邦式的、喋喋不休的、幽默与无奈并存的超现实文本。

作品源于两个学科（互动／平面设计）对各自学科内部基本问题边界的关注与回答。媒体互动的要义不再是基于"高技术"的编程为首要条件要素，强制性地将观者拉入语境，而是基于低技术甚至是无技术的物理媒介，以种种物质互动"现象"作为发展的出发点，在现象的过程中为观众提供理解和进入作品的多元渠道，同时呈现建立在事物内在逻辑基础之上的互动。作品将互动和平面设计两个学科以"概念"的形式链接起来。

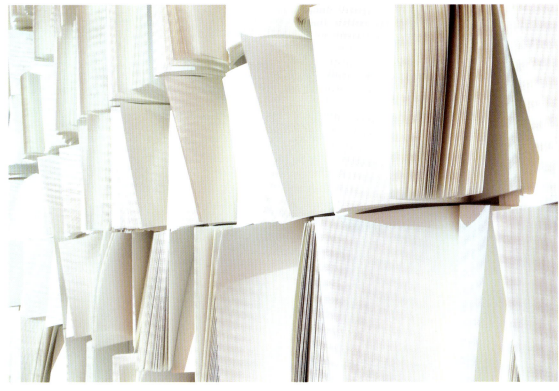

创作年代 / Date	2013
材质 / Material	书籍，工业电风扇，投影 / Books, Fan, Video
尺寸 / Dimension (cm) 长×宽 / Length×Width	270cm×208cm

The installation is composed of book pages and digital projection.

The work explores the relationship between questions and answers and their metaphoric meanings from two perspective, the physical interactions and conceptual languages. The contents of the digital projection are arbitrary questions raised by innocent children that do not have answers. The seemingly random collections and presentations of the questions actually reveal the boarders and limitations of human minds. They are also metaphors human beings' situation within the reality word. Asking a question is the first step of human being's exploration and understanding of the world, namely, thus the beginning of knowledge.

Projecting naïve, innocent questions onto the wall of empty books, which respond merely with the sound of flipping pages. Furthermore, digital projection, sound, physical movements of the pages create a surrealist text, as they have formed an everlasting, utopian conversation, which is humorous and useless.

The work originates from discussions of basic issues with the two fields (interaction and design). Interactions between different media have no long focused merely on high-tech programming that forces the audiences to focus on the context. Rather, they have concentrated on media with low or no techniques, which could provide various interactions between different materials, thus creating multiple access to the artwork, and revealing an inner logical link. Therefore, this work conceptually connects the disciplines of interactive physics and designs.

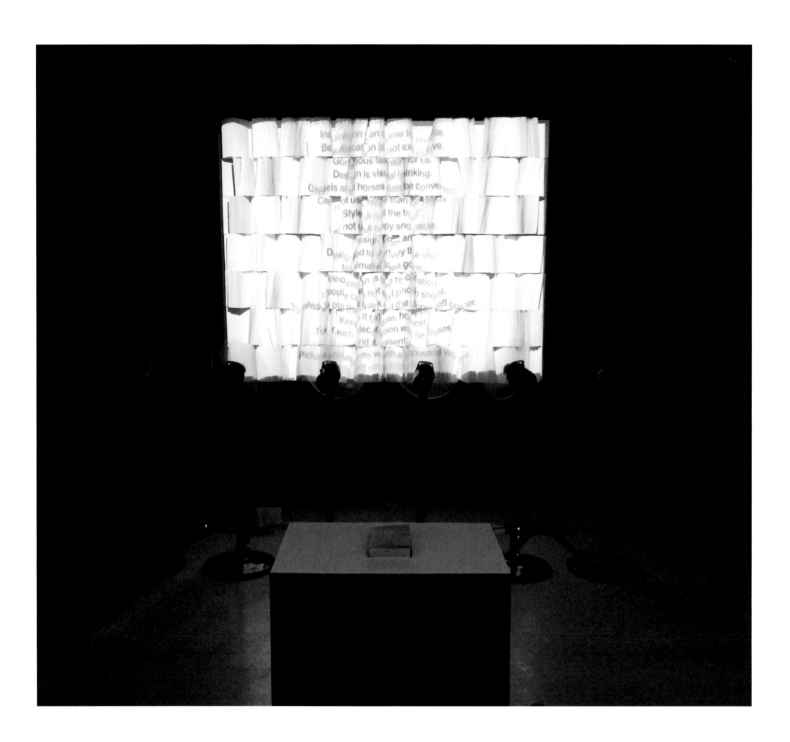

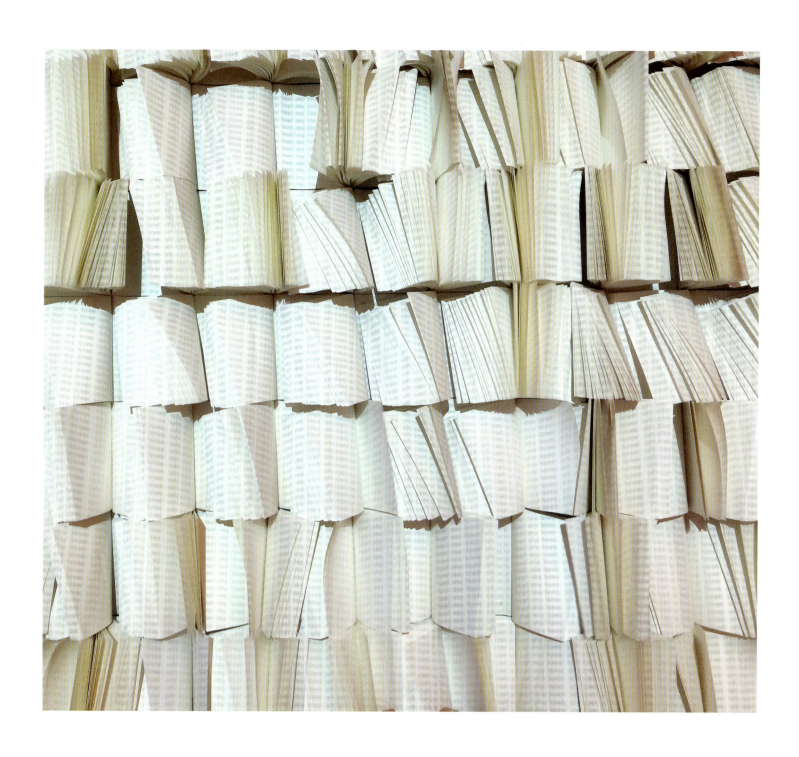

无限的限制 / THE INVISIBLE HAS LIMITS

伊夫·萨赫内（法国）/ YVES CHARNAY (FRANCE)

1966年，在为复制颜色处理而进行的打印和观察颜色选择过程中，我开始对颜色认知现象产生了兴趣。它是作为"总体艺术"事件一部分的"元艺术"组的创造，我开始使用浅色工作，并投入到我的第一个专利中。

细节："颜色阴影现象"。

颜色阴影现象的发生是由于我们大脑的曲解。当光源把一束光线照射到一个白色表面上时，它能够产生一个阴影。如果第二个光源照射到同一物体上时，第二个阴影就会形成。如果一个光源是彩色的，而另一个光源是白色的，奇怪的是两个阴影都是彩色的。通过在特定过程中构造阴影，颜色的种类就会增加。

我操作的这种特色工作在2002年，第一次通过德国萨克森-安哈尔特州议会的工作实现委任。该工作的标题为"精神的颜色"。另一项工作的模型已经最近完成，其名称为尼亚加拉颜色。我在本文中讲述的工作与2015年我所展示的"爱丽舍宫艺术"接近。

1672年，奥托·冯·格里克（1602-1686年）在一份观察报告中第一次历史性地提出了众所周知的"颜色阴影现象"。奥托·冯·格里克是一位工程师，而且是一位世界著名（他证明了大气压强现象）的德国物理学家。该证明就是众所周知的"马德堡半球"。

布冯（法国博物学家，1707-1788年）、加斯帕尔·蒙日（1746-1818年）、拉姆福德（1753-1814年）、歌德（1749-1832年）以及谢弗勒尔（1786-1889年）也相继观察了颜色阴影现象。

创作年代 / Date	2015
材质 / Material	铝板、滤光器、射灯 / Aluminum Plate, Filter, Shoot the Light
尺寸 / Dimension (cm) 长×宽×高 / Length×Width ×Height	100cm×400cm×100cm

In 1966, in a printing, observing the color selection process for reproducing the color process, I started to get interested in color perception phenomena. It is for the creation of the group "Meta-Art" as part of a "total art" event that I started working with light and put my first patent.

Particularities:
"The phenomenon of colored shadows."

The occurrence of colored shadows is due to a misinterpretation of our brain. When a light source illuminates a volume set on a white surface, it produce a shadow. If a second source illuminates the same object a second shadow is formed. If a source is colored and one white, curiously both shadows are colored. By structuring the shadows in a particular process, the number of colors can be multiplied.

This feature I operated the first time in 2002 for the realization of a work commissioned by Parliament of Saxony-Anhalt in Germany. The title of this work: Colors of the mind. Another work which the model was recently performed is entitled Colors in Niagara. The work that I present here is close to the one I had exhibited in 2015 at "Art Elysées".

In 1672, Otto von Guericke (1602-1686), noted an observation, the first historically, a phenomenon known as the "phenomenon of colored shadows." Otto von Guericke, was an engineer and famous German physicist in the world for his demonstration of the phenomenon of atmospheric pressure. The demonstration is known as the "Magdeburg hemispheres".

The phenomenon of colored shadows also successively observed by Buffon, a French naturalist (1707- 1788), by Gaspard Monge (1746-1718), for Rumford (1753-1814), Goethe (1749-1832) and by Chevreul (1786 -1889).

诗意书写在自然 / POETIC WRITING FOR NATURE
金江波（中国） / JIN JIANGBO (CHINA)

本次作品拟通过三个篇章来演绎中国的东方自然观、文字的结构艺术特征以及书法与自然的关系。再用摄像头感应器，捕捉现场的观众，让观众融入书法的文字森林与奇幻的水墨世界，现场观众与水墨影像互动共舞，真正达到人与作品的融合贯通。

1. 用三维建模古代山水画，变成魔幻山水空间动画。鸟、云彩、瀑布、彩虹、闪电等自然元素。墨水从天空滴入画面，像滴入水池一样涟漪了三维山水。魔幻的水墨山水化水墨凤凰、龙、太极效果为主。里面有各种各样的动植物元素、人物元素、自然元素穿梭飘逸。

2. 将以大气淋漓的古代书法精品为主，演绎水墨在纸张上，在宣纸中的力度，质感，草写，狂写，营造笔舞墨飞的三维空间效果。用三维建模的方式，营造出层层叠叠的书法字体的森林空间效果，彰显书法也是空间的艺术。一个水墨人物行走在书法森林里，光影婆娑迷离，魅影混沌。书法字体构成了密密麻麻的森林大道，光从天际下来，泄在森林书法字体的空间中，孤独的人在森林的深处起舞。

3. 优雅的字体慢慢飘逸在天空中，水雾弥漫，字体一个个飞向云端中，在云端上，在山顶上，翩翩起舞。山脉、文字、飞禽等等若隐若现从天空俯瞰水墨苍茫大地！长河远去消逝天边，书法字体幻变成黑客帝国般的水墨粒子空间！世界至此混沌消逝！

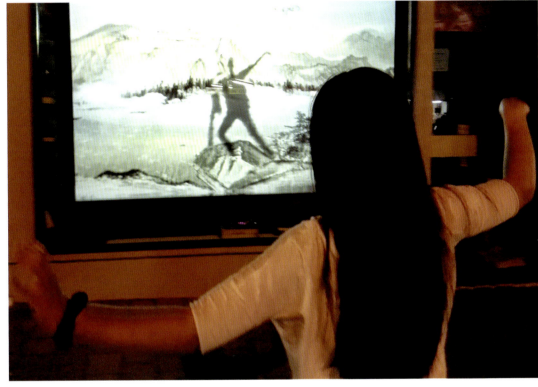

创作年代 / Date	2015
材质 / Material	互动影像 / Interative Video
尺寸 / Dimension (cm) 长×宽×高 / Length×Width ×Height	
空间 / Space:	500cm×300cm×290cm

This work, including three chapters, intends to interpret China's eastern view towards nature, the structure of the chinese characters and the relationship between calligraphy and nature. Using the camera sensor to capture the movement of the audiences on site, so that the audience can merge into the calligraphy of the forest and fantasy world of chinese painting, the live interaction between the audience and the chinese painting, achieving the integration of people and art works.

1. Modeling the ancient chinese landscape painting in 3D, the computer transfer the landscape painting into a magic spatial animation, containing birds, clouds, waterfalls, rainbow, lightning and other natural elements. Ink drops fall from the sky into the picture, like a trickle into the pool evoke ripples and transfer into three-dimensional landscape. The magic ink drop dramatically become Phoenix, Dragon and Tai Chi as the main character. There is also all kinds of animal element, people element, natural element moving gracefully.

2. Dominated by characteristic ancient calligraphy boutique, the interpretation try to express the ink movement on paper, using different 3D effect to manifest an ink pen dance of different status, like writing with power, writing in different texture, writing cursively or wildly scribble. With 3D modeling, creating a layer upon layer styles of calligraphy forest in spatial effect, highlighting the art of calligraphy is also spatial. A ink figure walk in the forest of calligraphy, gracefully ripple, acting like a phatom of the calligraphy. Calligraphy font constitute a high density forest Avenue, light drapple from the sky, relieving in the forest of calligraphy font space, lonely people dance in the depths of the forest.

3. Elegant calligraphy font slowly fly to the sky, up to the hill, up to the clouds, dancing gracefully with in the foggy sky. Mountain, calligraphy, birds and other element glance back at the ink painting earth from the sky, river gone away into the horizon, calligraphy magicaly change back to ink particle just like matrix! The world finally become back to chaos and vanish.

致虚极守静笃万物并作吾以观复夫物芸芸各复归其根归根曰静是谓复命复命曰常知常

神经元·创造，神经元·生长 / GENESIS, THE GROWING NEURON

王寅（中国）/ WANG YIN (CHINA)

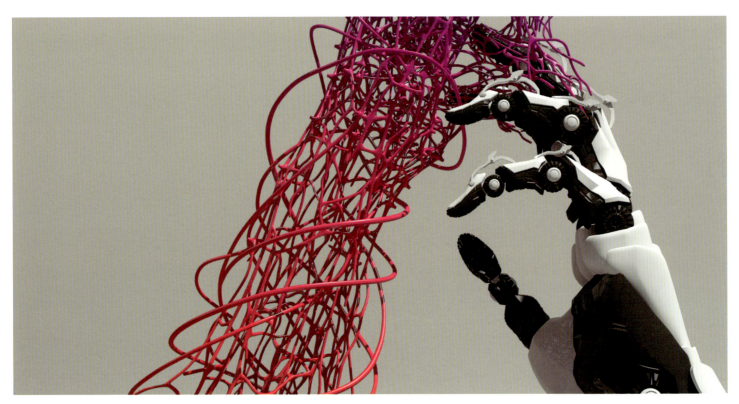

手，人类自身与生俱来的"工具"。进化过程里，人最先在四肢中解放了双手。同时，双手也是我们最熟悉、最灵巧的器官。而神经遍及我们身体内部，功能复杂多样，无时无刻不在传导着大量信息，我试图通过将常态下无法见到的神经元与我们最为熟悉的手相结合。

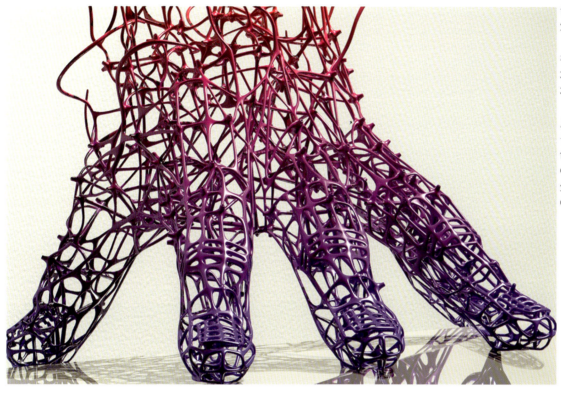

创作年代 / Date
2016

材质 / Material
3D打印、喷漆 /
3D Printing, Spray Lacquer

尺寸 / Dimension (cm)
长×宽×高 / Length×Width ×Height
创造作品 /
Genesis: 57cm×30cm×57cm
生长作品 /
Genesis: 39cm×44cm×53cm

Hands are human beings born "Tools". In the process of evolution, human beings first liberate the hands of their limbs. At the same time, hands are the most familiar and most delicate organs. Neurons is complex and diverse. It is transmitting a lot of information. I tried to combine the hands and the neurons.

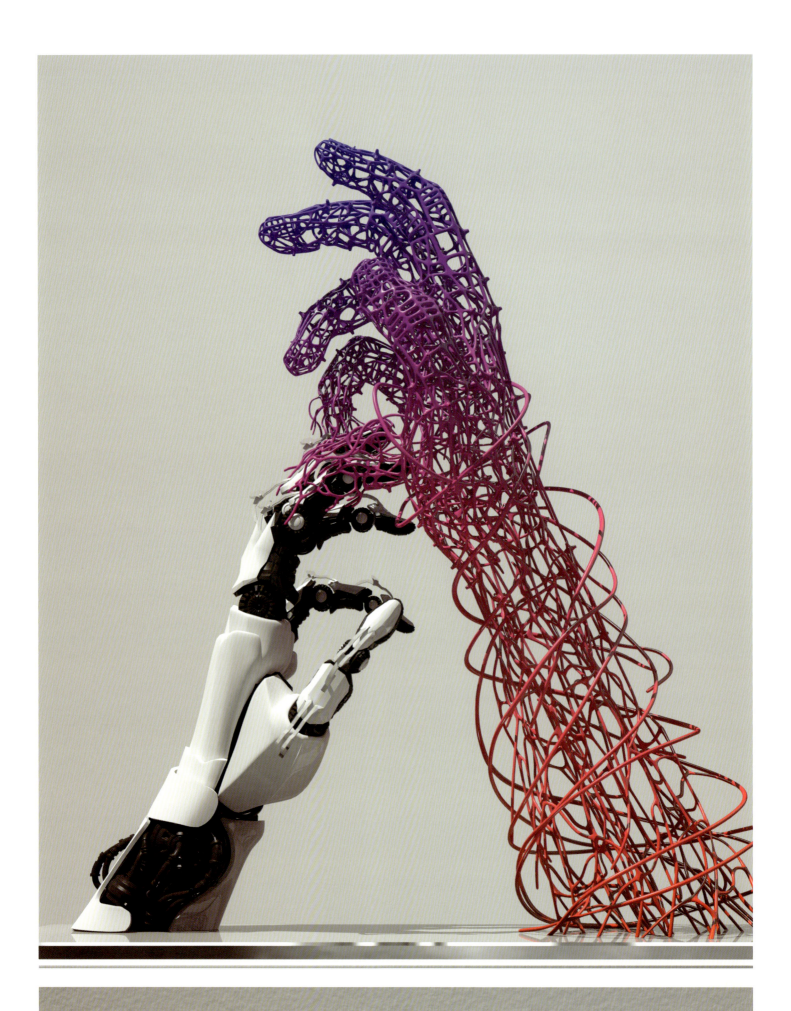

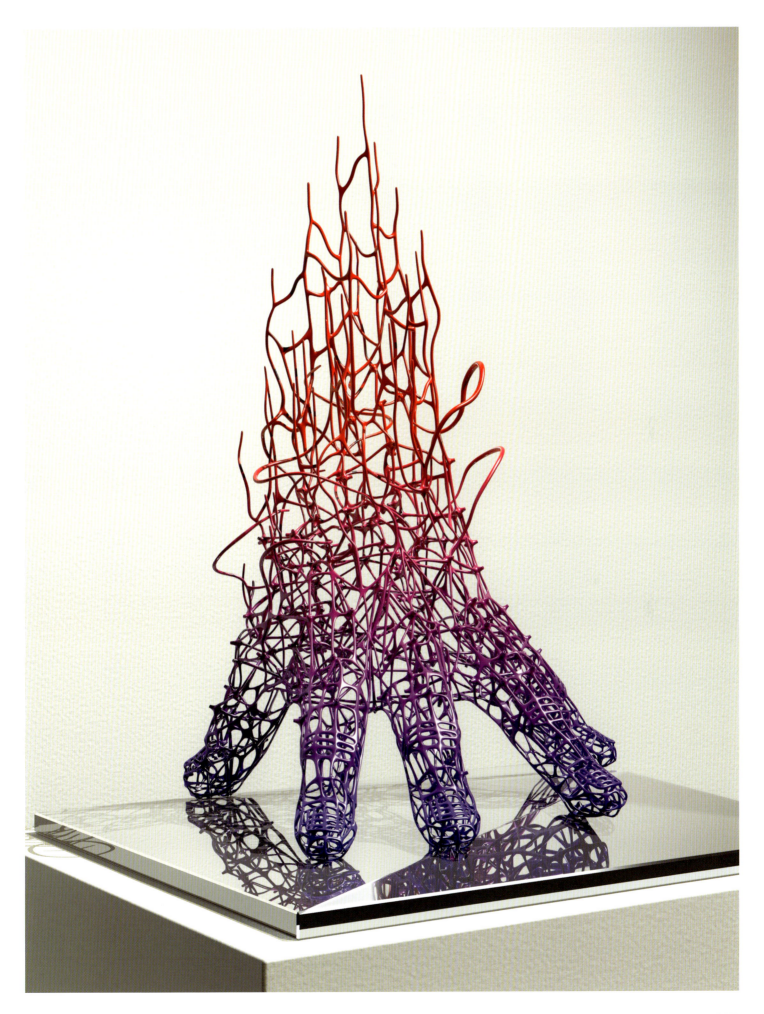

翔 / FLYING
张威（中国）/ ZHANG WEI (CHINA)

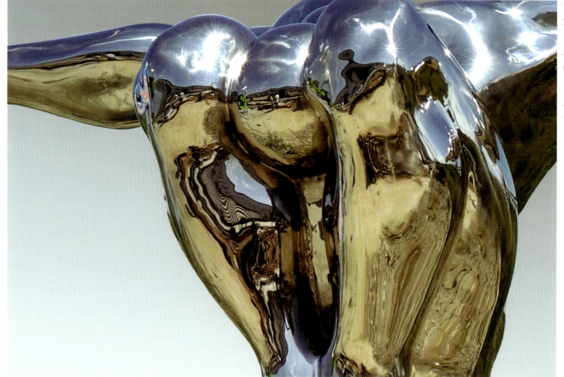

创作年代 / Date
2001

材质 / Material
镜面不锈钢 / Mirror Steel

尺寸 / Dimension (cm)
长×宽×高 / Length×Width ×Height
140cm×40cm×60cm

作品表现了人类对未来的憧憬与思考，并展开科学的臂膀自由的翱翔。镜面不锈钢的材质展现了科学技术对艺术作品表现力的延展，作品内容强调了自由思维对科学与艺术的重要性。

This art work try to express the human vision of the future and thinking, and spread out the arms of Science to fly freely. Mirror stainless steel material reflect the science and technology could extend the performance of art work, the content of the art work emphasis the free will is important for both science and art.

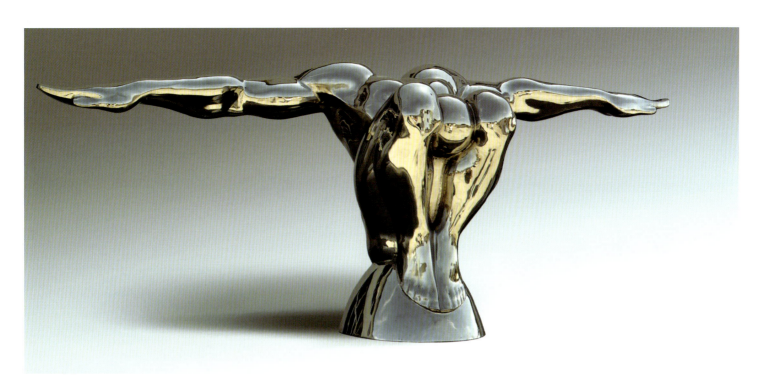
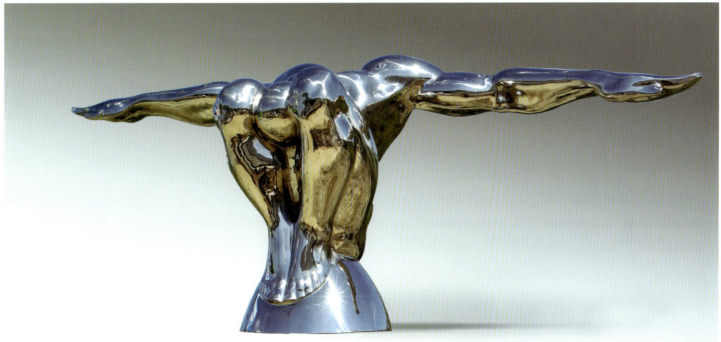

上上下下左左右右 / UP UP DOWN DOWN, LEFT LEFT RIGHT RIGHT
胥泓州（中国）/ XU HONGZHOU (CHINA)

创作年代 / Date
2014

材质 / Material
金属着色 / Metal

尺寸 / Dimension (cm)
长×宽×高 / Length×Width ×Height
40cm×40cm×40cm

人的大脑运算系统本是非常复杂的，对于思考与感受会以相当复杂的模式进行运算，但随着科技的发展，辅助人们思考与感受的器械、设备越来越多，功能越来越强大，从而使得对于"答案"的追寻变得高效与便捷，我们的思维模式也逐渐开始固化。抛去我们的天赋，剩下的只有点与点之间最短距离的直线（简单的思考），和两个直角便可产生的空间（简单的感受）。这种惯性会使我们原本的可生长的天赋变得枯萎、不稳定，最可怕的是变得对自然麻木。当人们失去灵性该如何与自然对话？

The human brain computing system is very complex, which the thinking and feeling process will be calculated in a rather complicated pattern, but with the development of science and technology, more and more equipment and appartus is designed to help people think and feel, and its function become more and more powerful, thus making the pursuit of "answer" become more and more efficiency and convenience, our thinking pattern become conservative and inflexible, loosing our inate gift, only linear way of thinking and simply feeling towards the outside world, and this inertia thinking will make the original growth of our talent become withered and unstable, excessivly dependent on the machine and equitment that we built, and the most terrible of all is to become numb to nature, when people lose the intelligence, how to continued the dialogue with nature?

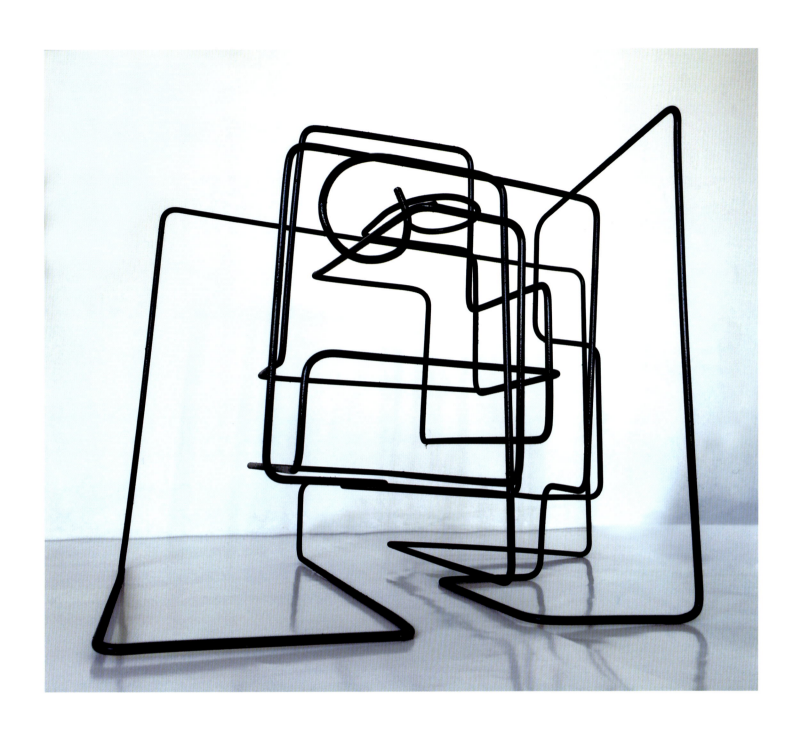

空间设计 / SPACE DESIGN

2016_10
乌鲁木齐市宏美术馆
MACRO ART MUSEUM OF URUMQI CITY

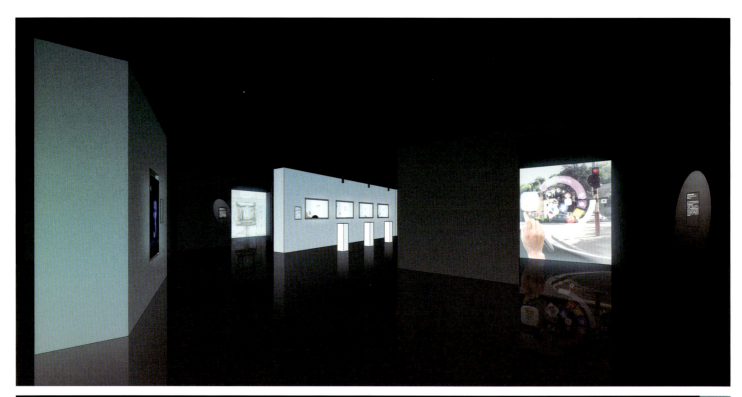
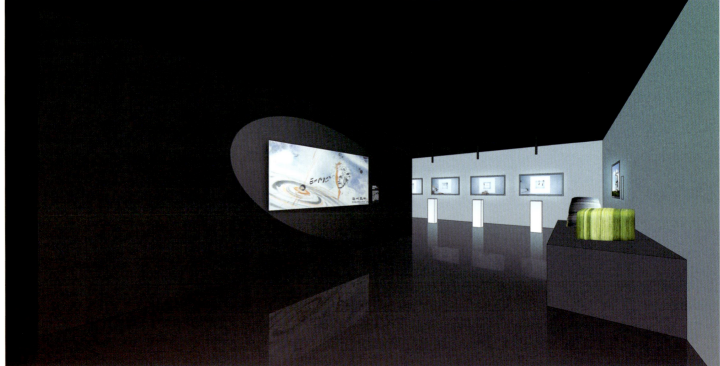

后记 / POSTSCRIPT
杨冬江 / YANG DONGJIANG

如果说科学之光像一座灯塔，照亮了未知和指明了方向；艺术之光则像一团火种，点燃了人类的热情和永续不断的创造力。没有科学精神无以至未来，没有艺术涵养无以至恒远，科学与艺术相互对话、相互促进、相互守望是时代发展的必然趋势，本次"艺术与科学的对话——第二届中国新疆国际艺术双年展"，也正是回应这一历史和时代的命题。

当下世界正发生快速而复杂、深刻而剧烈的变化，"一带一路"的互联互通将为新疆带来战略机遇，推动沿路各地区科技、文化、艺术、经济发展战略的对接与融合。通过这次展览、利用艺术与科技对话的契机，希望国际主义与地域文化、东方文明与西方文明、科技艺术与日常生活在新疆——这一古往今来都是文化交融的宝地，开启新一段文化艺术互鉴共荣、科学技术互利互助的新纪元。回顾历史，丝绸之路纵横交错于亚欧大陆之间，以至下而上的商贸之旅连接了社会经济、科学艺术、东西文明的方方面面，它生生不息地见证了各个时代的天文、地文、水文、人文的变迁，记录了沿线所有不变和变化的信息，留下历史上难以磨灭的印记：丝绸之路以人、以器物传播文化和技术，对帕米尔高原至塔里木盆地周缘的绿洲产生了深远的影响，保存至今的古城遗址、宗教建筑、壁画雕塑和艺术构件，都隐含了丝绸之路新疆段建筑文化和艺术创作的独特性，留下东西交流融合的永恒痕迹。在互联互通的"一带一路"新纪元中，自下而上、自上而下都已成为通路，新疆的艺术与文化凭借本身的包容与地域民俗特色，借鉴当代国际艺术的创新理念与技术手段，必将有新一批的优秀作品涌现，推动新疆文化与艺术作品走向国际舞台。

如果说"艺术与科学"的是时代命题，"一带一路"回应的是区域战略问题，在展览作品的选择上，组委会更希望将这两个宏大的时代与区域命题，以一种微观的、具体的、人本的方式进行形象表述。艺术与科学展览的主要发起者、诺贝尔物理学奖得主李政道先生曾经指出"科学和艺术的共同基础是人类的创造力，它们追求的目标都是真理的普遍性"，李政道先生的精辟阐释，也正反映、印证了这次展览组织展品的宗旨与核心价值观。因此，在本届双年展中，作品的选择会注重作品与自然、与人类的关系，遴选的作品大多体现科学与艺术在人这个层面上的交融和所发生的启发性对话，不遗忘历史、不止步于当下、面向于未来的深度智慧凝结和有益实验是评选的标准。

这次展览共有来自英国、法国、奥地利等7个国家，共计28件作品参展，每个展品都经过了严格的专家评选和论证。本次展览共分为"科技与智造"、"生态与人居"、"信息与智能"、"自然与生命"四大板块，将前沿科技与智造紧密结合、生态绿色技术与人居环境的改善结合，让信息技术和智能技术为历史、为当下、为未来提供互动与借鉴，让自然与生命成为有机整体、共生共荣，是此次展览作品里的共识与共建目标。

在此，要衷心感谢各界领导、各国友人、各级政府机关、各地高校和同行同仁对于展览所给予的支持，感谢文化部艺术司、自治区文化厅对于清华大学美术学院的信任，感谢整个策展团队为本次展览付出的心血与汗水。希望这次展览成为大家后续合作探索、共同研究、协同创新的开端，让科学与艺术在新疆开出最美的西域之花、结出创新融合之果。

后记 / POSTSCRIPT
杨冬江 / YANG DONGJIANG

People may say science is like a beacon to point to the unknown and the right direction, then art must be the kindling to illuminate the passion and sustaining creativity of the human being. Without the spirit of science, there's no way to touch the future; but without the deposit of art, there's no access to eternity. The dialogue, mutual promotion and support between science and art are inevitable trends of the era, and the "Dialogue between Art and Science—2nd Biennial Int'l Art Expo Xinjiang, China" was a response to the topic of history and the era.

With rapid, complicated, profound and strong changes around the world at present, the connectivity of the "One Belt and One Road" will guarantee Xinjiang strategic opportunities and help boost the interconnection and integration in technology, culture, art and economic development strategy among areas along the Belt and Road. By this exhibition and by virtue of the dialogue between art and sci-tech, it's hoped that a new epoch for the common prosperity of culture and art and the mutual assistance of science and technology will be launched in Xinjiang, the long-standing treasure land of cultural integration, by internationalism and regional culture, Oriental civilization and Western civilization and sci-tech and art and everyday life. Looking back on the history, it's not hard to see that the Silk Road covered the whole Eurasia and connected all aspects of social economy, science and art and Oriental and Western civilizations by commerce and trade from bottom to top; it never ceases to witness the changes of astronomy, geography, hydrology and humanity and record all the unchanging and changing information along the road to leave inerasable imprints in the history. By people and utensils, the Silk Road disseminates culture and technology to exert far-reaching influence on the oasis ranging from Pamirs to Tarim Basin, and the relics of ancient cities, religious architectures, murals and sculptures and art components preserved till today embody the uniqueness of Xinjiang Section on the Silk Road in architectural culture and artistic creations to leave the eternal traces of Oriental and Western communication and combination. During the new epoch of the "One Belt and One Road" of interconnectivity that features channels both from bottom to top and the other way, the art and culture of Xinjiang relies on its inclusiveness and regional and local characteristics and learns from innovative ideas and technological means of contemporary int'l art, so that new generations of outstanding works will emerge to promote works of Xinjiang culture and art onto the int'l stage.

"Art and science" is a theme of the era, and "One Belt and One Road" responds to the issue of regional strategy; therefore, in selecting exhibits, the organizing committee wished to present a vivid expression of the two grand topics of the era and the region by a microscopic, specific

and human-centered means. Mr. Tsung-Dao Lee, Nobel Prize winner and a chief initiator of the Art and Science exhibition, pointed out that "the common foundation for art and science is human creativity, and they both seek the universality of truth." The penetrating explanation of Lee fairly reflects and proves the tenet and core value of the exhibition's selection of exhibits. Therefore, during the expo, the selection of works stressed the relationship between the works and nature and human beings, and most of the works listed demonstrate the integration between science and art at the level of human beings and the enlightening dialogues thus incurred. Condensation of deep wisdom and encouraging experiment that embrace the history, keep pace with the present and face the future are the norms for selection.

Showing 28 works from seven countries, such as the UK, France and Austria, the exhibition guaranteed strict selection and argumentation by experts for all exhibits. Including four modules, namely, "sci-tech and smart manufacturing", "ecology and human settlement", "information and intelligence" and "nature and life", the exhibition tied up advanced sci-tech with smart manufacturing and improved the bond between ecological and green technologies and human settlement, so that reference can be obtained from information technology and smart technology for the history, for the present and for the future and nature and life will become an organic whole for common prosperity: these are just the consensus of the exhibits and the common goal embodied in them.

I would like to extend my sincerest thanks to relevant departments, guests from all countries, universities and peers for your support to the expo, and to the Department of Art of the Ministry of Culture and the Department of Culture of Xinjiang Autonomous Region for your trust in the Academy of Arts and Design, Tsinghua University; I would also like to express my gratitude to the curation team for your efforts in the expo. Hope this event will serve as the beginning of follow-up cooperation and exploration, common researches and coordinated innovations, so that science and art will bloom beautifully in beautiful Xinjiang and bear fruits of innovative integration.

图书在版编目（CIP）数据

艺术与科学的对话　　第二届中国新疆国际艺术双年展作品集/第二届中国新疆国际艺术双年展组委会编；鲁晓波，杨冬江主编 .—北京：中国建筑工业出版社，2016.9
ISBN 978-7-112-19930-3

Ⅰ. ①艺… Ⅱ. ①第… ②鲁… ③杨… Ⅲ. ①艺术—作品综合集—世界—现代 Ⅳ. ①J111

中国版本图书馆CIP数据核字（2016）第225825号

本书是艺术与科学结合而产生的国际知名作品的一次全面结合，共划分为科技与智造、生态与人居、信息与智能、自然与生命四大部分，汇集了来自7个国家的28件作品，每个作品分别以自身独有的表现形式以开放的思维和角度体现了当代艺术与科学领域的最新成果。为当下和未来提供互动与借鉴，让自然与生命成为有机整体、共生共荣。本书适用于绘画、影像、装置、摄影、数字媒体及艺术设计相关专业从业者、爱好者和在校师生阅读。

责任编辑：唐　旭　吴　绫　李东禧　张　华
装帧设计：倦勤平面设计工作室
责任校对：姜小莲

艺术与科学的对话
Dialogue Between Art & Science
第二届中国新疆国际艺术双年展作品集
A Works Collection of The 2nd Xinjiang
International Art Biennial, China
第二届中国新疆国际艺术双年展组委会　编
鲁晓波　杨冬江　主编

*

中国建筑工业出版社出版、发行（北京西郊百万庄）
各地新华书店、建筑书店经销
倦勤平面设计工作室制版
北京方嘉彩色印刷有限责任公司印刷

*

开本：965×1270 毫米　1/16　印张：8　字数：300千字
2016年9月第一版　2016年9月第一次印刷
定价：**108.00**元
ISBN 978-7-112-19930-3
（29434）

版权所有　翻印必究
如有印装质量问题，可寄本社退换
（邮政编码 100037）